ROYAL ACADEMY ILLUSTRATED 2005

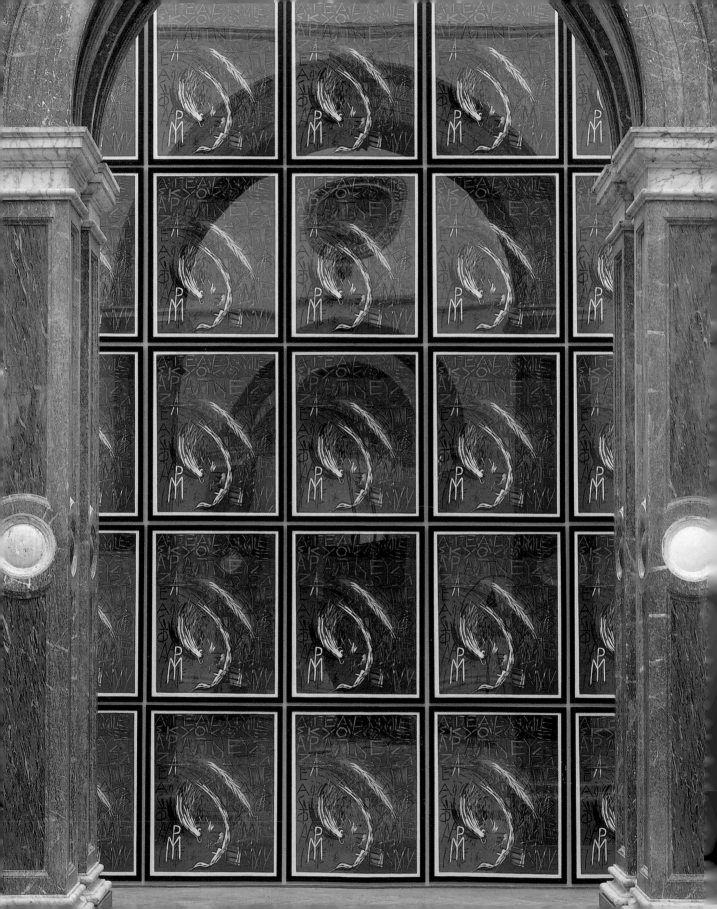

'Poetry through mechanics'
Chris Orr RA

ROYAL ACADEMY ILLUSTRATED 2005

A selection from the
237th Summer Exhibition

Edited by Chris Orr RA and
Stephen Farthing RA

ROYAL ACADEMY OF ARTS

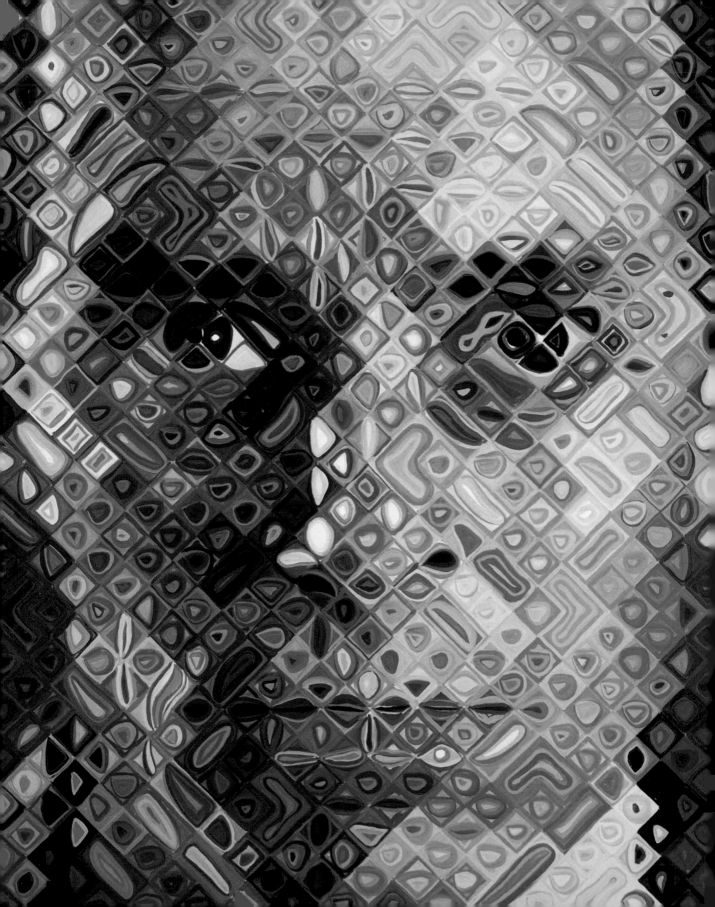

Contents

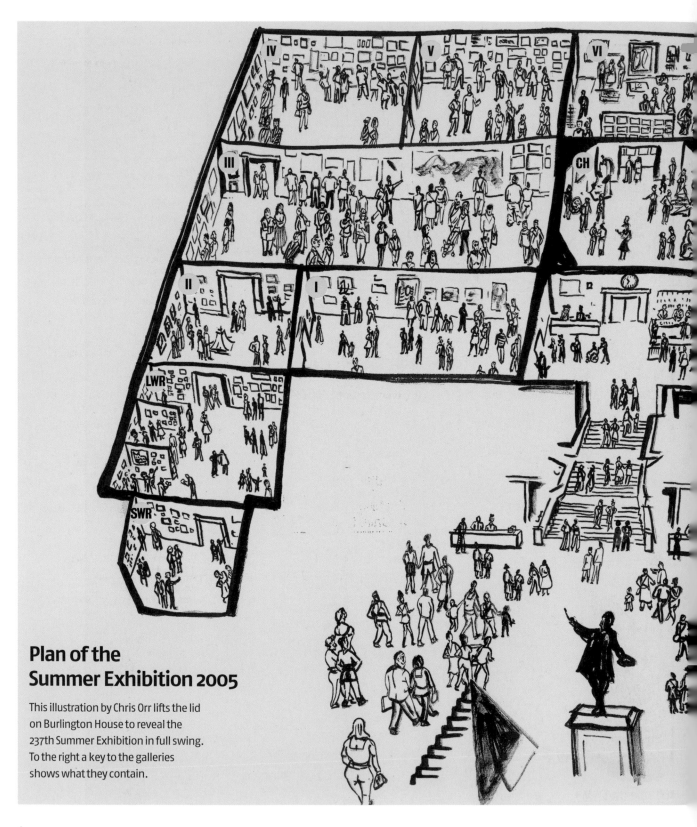

Plan of the
Summer Exhibition 2005

This illustration by Chris Orr lifts the lid
on Burlington House to reveal the
237th Summer Exhibition in full swing.
To the right a key to the galleries
shows what they contain.

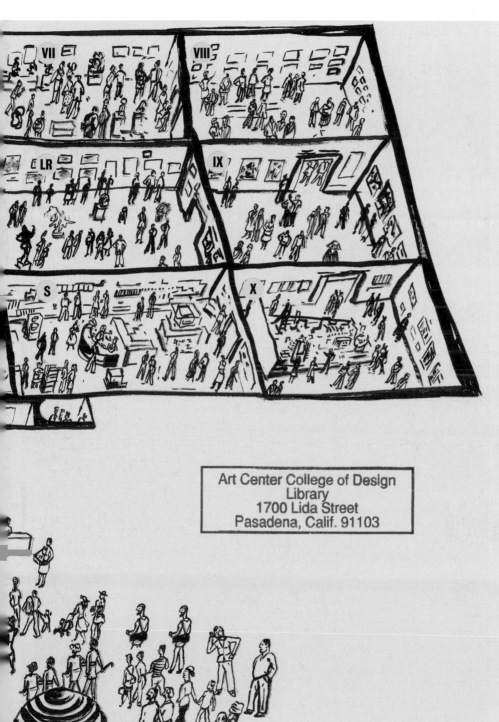

KEY TO THE GALLERIES

The Annenberg Courtyard
David Nash RA

I
Harry and Carol Djanogly Gallery
Honorary Academicians

II
Harry and Carol Djanogly Gallery
Invited artists

Large Weston Room (LWR)
Prints

Small Weston Room (SWR)
Small paintings and works on paper

III
The American Associates Gallery
*Large paintings and works on paper
by Academicians*

IV
*Academicians and works from open
submission*

V
The Jeanne Kahn Gallery
*Academicians and works from open
submission*

VI
The Philip and Pauline Harris Gallery
Prints and multiples

Central Hall (CH)
The Wohl Central Hall
Sculpture

VII
The John Madejski Gallery
Sculpture and works on paper

VIII
The Weldon Gallery
Ed Ruscha, featured artist

IX
The John A Roberts FRIBA Gallery
Large paintings

Lecture Room (LR)
*Academicians and works from open
submission*

X
The Porter Gallery
Architecture

Shop (S)

Foreword
Chris Orr

The 237th Summer Exhibition has a theme: the multiple image and printmaking in all its manifestations. Over the years the Print Room in the Summer Exhibition has become increasingly popular. Commercially successful and artistically interesting, it shows work that not only sells but also reveals a wide range of printmaking techniques. This year's Summer Exhibition offers the same extraordinary range of media and artistic invention, but focuses attention on works that use traditional as well as new printmaking technologies.

Artists have always wanted to make poetry through mechanics. Many of the greatest artists – from Rembrandt, Blake and Goya to Munch, Picasso, Rauschenberg and Hockney – have made printmaking central to their artistic output. Prints are a uniquely sensitive and graphic way of expressing ideas, and many artists today are alive to a world that is buzzing with printed and virtual imagery and the visual and communicative potential it offers.

This exhibition contains works by artists who translate their ideas through woodcut and etching, processes that go back centuries; by those who use innovative print techniques, such as photography and video; and by those who employ inkjet, giclée and other processes that are derived from new technologies.

Whether artists are using pencils or computers, and whether they are producing works of art in an edition of one or 1,001, this year's Summer Exhibition shows the enormous possibilities afforded by printmaking in all its manifestations. The show's democratic nature is also mirrored in the number of works submitted from overseas. Alongside famous names are works by artists from as far afield as Australia and China, proving once again that the Summer Exhibition is a celebration of quality and diversity.

The Multiple Image
Frank Whitford

Ever since the first image was struck from the inked surface of a relief-cut block of wood over 1,000 years ago, printmaking has had a hazy reputation. True, there is general agreement about its supreme achievements (Dürer's woodblock prints and engravings, the etchings of Rembrandt and Picasso, and Toulouse-Lautrec's lithographs, to cite the most obvious examples), but a tenacious and widespread belief lingers that, in the family of artistic media, prints are the poor relation. (As though to prove the point, the standard art-historical surveys neglect printmaking almost completely.)

So the decision to feature not only prints but what might best be described as a variety of 'multiple images' in this exhibition could not have been an easy one. There is an emphasis on them at almost every point in the exhibition, and not just in the Large Weston Room, which is traditionally reserved for a celebration of a wide variety of printmaking.

Prints hold their own with paintings in the first gallery of all, where several Honorary RAs, among them Robert Rauschenberg, Frank Stella and Antoni Tàpies, together suggest something of the extraordinary range of modern printmaking. Gallery II is dominated by prints, all by invited artists, among them Helen Frankenthaler (page 28), James Rosenquist (pages 36–37) and Chuck Close (page 38), whose close-up, larger-than-life images of the human face are as powerful as his paintings of the same subject.

Gallery VI is also reserved for prints and other kinds of multiple techniques in two and three dimensions. Some involve computers and digitisation; others, like Mimmo Paladino's woodcut in several colours, were printed using one of the oldest techniques of all. Paladino's print was originally made for the 2004 Athens Olympics, and much of the edition of 300 covers an entire wall (page 2).

Sue Jin Lee
1/6 [900]
Dice
48 × 47 cm

The impact is undeniable, and the multiplicity makes the image commanding.

Gallery VI also includes multiples: that is to say objects designed, and sometimes made, by artists in limited editions. One of them is Paul Winstanley's portable exhibition of his work in miniature, *Six Paintings in a Box*, the paintings themselves reproduced as cast plastic transfers. A multiple of another kind is Sue Jin Lee's *1/6 900* (opposite), a geometric abstraction created by juxtaposing numerous red dice, with either one or six dots uppermost. Tom Phillips uses a row of books entitled *What Is Art?* (page 116) by the now forgotten critic D. S. MacColl to suggest that the answer to this particular question will forever be hidden, like the books behind their spines. Colin Self's delightfully witty *Clive Barker Forgery (No. 1)* (page 13) might be described as a partially readymade multiple, since it uses chromed-brass off-the-shelf bathroom fittings to make part of an old-fashioned aeroplane, with taps forming the engines and propellers. The multiple is physically manifest in this catalogue, which includes a Gary Hume print in a special edition of 3,000 copies.

It was Chris Orr, an RA since 1995, who suggested that the theme of this year's Summer Exhibition should be multiple images. This is unsurprising, given Orr's own distinction as a printmaker (several of his prints in a variety of media can be seen in the exhibition) and a teacher of printmaking. (He has been Professor of Printmaking at the Royal College of Art since 1997.) Orr's purpose is not simply to show as many prints and multiples as possible. He also wants to stress that a 'once less important activity is again at the heart of art practice'. It's certainly true that many artists are today making prints alongside their main activities as sculptors or painters. 'What's more,' adds Orr, 'much modern printmaking is the result of close collaboration, at the very least between the artist and the specialist printer or technician. Collaboration is one of the most obvious characteristics of contemporary art. If you lack a particular skill you know where you can buy or borrow it. And no-one thinks the worse of you for it.'

Orr hopes that the exhibition will suggest ways in which the practice of printmaking is being extended and redefined. 'We haven't by any means excluded the wide range of traditional techniques, but we also want at least to hint at what the future of printmaking – and that means the future of art – might be.'

Orr is one of two co-ordinators of the exhibition, a responsibility previously undertaken by the Senior Hanger, literally the longest-serving RA on the Council. The other co-ordinator is Stephen Farthing, elected an RA in 1998, and recently appointed to the Rootstein Hopkins Chair of Drawing at the University of the Arts, London. (One of Farthing's contributions to the exhibition is a spit-bite etching, *Washington, Crossing the Frozen Delaware no. 3*; page 48). Like Orr, Farthing argues that printmaking is today one of the most important and influential artistic activities. This is not simply because of the large number of artists of every kind who regularly make prints. 'So much art isn't conceived with pencil and paper any more, but on the computer screen,' he says, 'and printmaking is responding to the enormous possibilities afforded by technology more creatively than any other medium.'

Farthing has another reason for drawing attention to printmaking in the Summer Exhibition. 'Because it's constantly moving into new creative territory, it's especially interesting and stimulating for young artists. The Academy must attract the attention of young artists if it's to survive and prosper, and it won't appeal to them if every Summer Exhibition limits itself to showing work in traditional media.'

Both Farthing and Orr are, of course, aware of the relatively low status that was accorded to printmaking for most of its long history, thanks mostly to the way it was viewed as an essentially commercial activity. After all, Dürer never denied that his prints were chiefly a means of making money. (He even sent his wife to fairs to sell them.) There's a suspicion that this is why most artists make prints. Certainly the search for profit has made it difficult to answer the question about what is a genuine, original artist's print, and what should count as a mere reproduction. Artists, Picasso and Francis Bacon among them, have been known to sign quite ordinary reproductions of their paintings. That does not make them original prints at all, of course, and one of them is, in fact, worth less than an unsigned pull of one of Picasso's etchings.

But the main reason for the pervasive prejudice against printmaking (and more specifically engraving) used to be the status of those who practised it. They were regarded less as artists than craftsmen.

Before the arrival of photography (and for some time after it) engravers applied their considerable skill and experience (while ruining their eyesight) not to making original works of art but to copying and reproducing paintings and sculptures by others.

The history of the Royal Academy itself tells us much about the almost universal discriminatory attitude to engravers. William Blake, for example, studied at the Royal Academy Schools after completing an apprenticeship as an engraver, but was never elected an RA. True, he made no secret of his hatred of Reynolds and his theories. To many he seemed at best anti-socially eccentric, at worst mentally unstable. Yet surely the true reason why he was never elected to the Academy was his preferred medium. No engraver could be regarded as the equal of a painter; no mere engraver, no matter how brilliant or original, could ever be taken entirely seriously.

The Academicians relied heavily on engravers, of course. These masters of the mezzotint and other multiple techniques copied paintings and sculptures by their betters and made them well known. The copyists were amazingly skilful and technically brilliant.

Yet their status remained low. For a long time, together with wax modellers and animal painters, they remained the poor relations at the Academy.

It is not widely known that an Academician is elected into a particular category of artist, the most obvious being those of architect, painter and sculptor. The category of engraver did not exist in 1768, when the Academy was founded, and when engravers protested against this discrimination, they were told a year later that the best they could hope for was associate status. According to the existing dogma, they were doomed for all time to be inferior. In 1812 a statement by the Council of the Academy made this unambiguously clear: 'The relative pre-eminence of the arts has been estimated… as they…abound in those intellectual qualities of Invention and Composition, which Painting, Sculpture and Architecture so eminently possess, but of which Engraving is wholly devoid; its greatest praise consisting in translating with as little loss as possible the beauties of these original Arts of Design.' Engraving, in other words, though high on form was low on original content.

This view of engravers as mere copyists was to ensure their exclusion from full membership of the Academy for four more decades. They achieved the formal status of Academician in 1853, but were still not entirely the equals of the painters, sculptors and architects even then. Another 75 years were to pass before they were treated as true equals, and by then attitudes to printmaking in general had changed totally. Today the engraver's category of Academician also embraces draughtsmen and printmakers. Among such members are Jennifer Dickson, Allen Jones, Norman Ackroyd, Tom Phillips and Joe Tilson, and all have work in this exhibition. Times have changed indeed – and so have prejudices.

Why and when did attitudes to printmaking change? The most important reason was the invention of photography and photo-mechanical means of reproduction during the second half of the nineteenth century. Engravers, their function usurped by technology, found themselves unemployable. But they were also liberated from commercial restraints, and the more enterprising among them were able for the first time to think more closely about the artistic potential of their demanding medium.

This is not the place for a history of printmaking. Some attention must nevertheless be paid to a few important landmarks in its modern history. One is the revival of etching by Whistler (significantly, one of the first to hand-sign his prints) and Alphonse Legros in the 1860s. Another is the transformation of lithography from a commercial into an artistic medium, first by Daumier, and then, in the 1890s, by Toulouse-Lautrec. Also important is the revival of the woodcut, first by Munch and Gauguin, and, after 1905, by Kirchner, Nolde and other members of Die Brücke in Germany. Then,

around the middle of the last century, there is the widespread adoption by artists of silkscreen, more or less concurrently in Britain and the United States. Finally there is the impact made by technologically sophisticated, computer-driven techniques which have added an entirely new dimension to the imaginative treatment of visual images.

One of the first to use silkscreen was Robert Rauschenberg, who employed it together with solvent transfer and other printing techniques in his 'combine paintings', attempting to achieve a synthesis of the mechanical and the personal, of the real and the imaginative. (A much more recent Rauschenberg diptych employing silkscreened photographs can be seen in Gallery I.)

Since the early 1960s Rauschenberg's influence has been one of the reasons for the imaginative breadth and technical originality of American printmaking. There's scarcely a major artist, from Jasper Johns to Keith Haring, who has resisted the possibilities of a variety of print techniques, often encouraged and assisted by a print studio and publishers. Rauschenberg himself benefited from the technical expertise of U.L.A.E. (Universal Limited Art Editions) and Gemini G.E.L. (Graphic Editions Limited).

Many other artists have worked with the equally celebrated Tamarind Institute, and the Ken Tyler studio. One is Frank Stella, whose unusually large print – a combination of etching, aquatint and relief engraving – from his *Moby Dick Dome* series is published by Tyler and hangs in Gallery I (page 23). Such large formats and complex techniques are perhaps only possible with the aid of highly skilled printers and the kind of advanced technology that publishers like Tyler provide.

Even before Rauschenberg began to experiment with silkscreened images in the United States, Eduardo Paolozzi was using the once-despised technique, then employed exclusively for commercial purposes, in Britain. Working with Nigel Henderson, he at first used it to print wallpaper, fabrics and even decorative tiles, but he quickly came to apply it first to the reproduction of his collages, and then as a medium in its own right. His series *As Is When* (1964–65), inspired by episodes from the life of the philosopher Ludwig Wittgenstein, is arguably the first masterpiece in silkscreen, a technique Paolozzi continued to use brilliantly until the end of his career. (Two of his later silkscreens can be seen in the Large Weston Room; a detail of one is on page 9.)

As Is When was published by Editions Alecto, pioneers of print publishing during the 1960s and 1970s who gave painters and sculptors as well as printmakers the freedom to originate and realise their ideas in multiple form. A partial list of the artists whose prints Alecto published demonstrates the company's importance in the history of printmaking, and also its foresight in commissioning artists who, though not chiefly printmakers, extended the

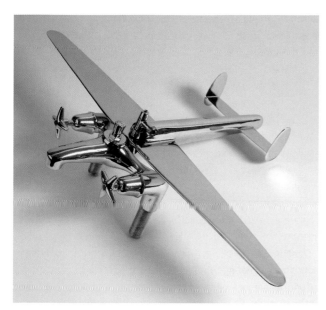

Dr Colin Self
Clive Barker Forgery (No. 1)
Chrome-plated brass
H 22 cm

boundaries of the medium and enriched its creative possibilities. Apart from *As Is When*, Alecto published, within the space of a few years, David Hockney's suite of etchings *A Rake's Progress* (1963); Allen Jones's series of lithographs *Concerning Marriages* (1964); several of Richard Hamilton's screenprints, including *The Solomon R. Guggenheim* (1965); Jim Dine's screenprints *A Tool Box* (1966); a suite of colour etchings and aquatints by Jennifer Dickson called *Alecto Keys* (1961–64); organic screenprints by Ed Ruscha called *News, Mews, Pews, Brews, Stews and Dues* (1970); as well as individual prints by Gillian Ayres, Tom Phillips and Colin Self. It's striking that all these artists are represented by prints in this exhibition, testifying not only to the importance and foresight of Editions Alecto but also to the artists' continuing commitment to printmaking.

It's striking, too, how many of these distinguished printmakers were associated with Pop Art. Screenprinting attracted them as a technique because of the way it took any number of disparate images from a wide variety of sources and endowed them with visual unity and coherence. (The number of outstanding silkscreen printers in London, especially Chris Prater and Christopher Betambeau, was also a crucial factor.) Many of the Pop Art generation continue to employ the medium, as can be seen in examples of work by Peter Blake, Allen Jones and Joe Tilson in this exhibition.

Of course, printmaking has moved on since the arrival of silkscreen. Today, the artist is offered the huge (and still largely unexploited) potential of technology and digitisation. Bewildering to the layman, probably threatening to older generations of artists, it is taken in their stride by the young, to whom the art-school computer room was as familiar as the studio, perhaps even more so.

For all the emphasis on such modern and relatively modern techniques as inkjet, giclée and digitisation in this exhibition, traditional print media have not been neglected at all. Like its predecessors, this Summer Exhibition demonstrates that there is still abundant life in the woodcut, the lithograph and the etching. Among this year's invited artists is one of the greatest living etchers working today, Lucian Freud, whose *Painter's Garden* (page 34) somehow succeeds in emulating the physicality of his oils. Avigdor Arikha's superb small drypoints of people are one of the outstanding features of Gallery II (page 39). There, too, are drypoints of shamelessly sexy but also sinister cats by Louise Bourgeois (page 31). The traditional and time-honoured together with the progressive and experimental: this is the mixture that every Summer Exhibition strives for. Perhaps this year's exhibition also manages to realise Chris Orr's ambition of showing that 'printmaking is today at the centre of all artistic creativity'.

THE ANNENBERG COURTYARD

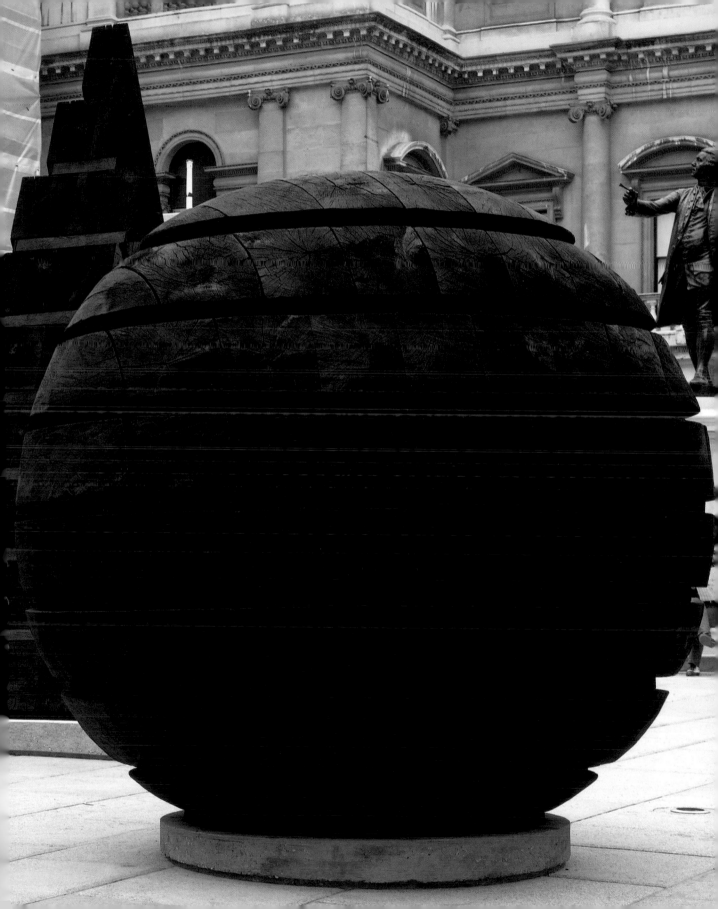

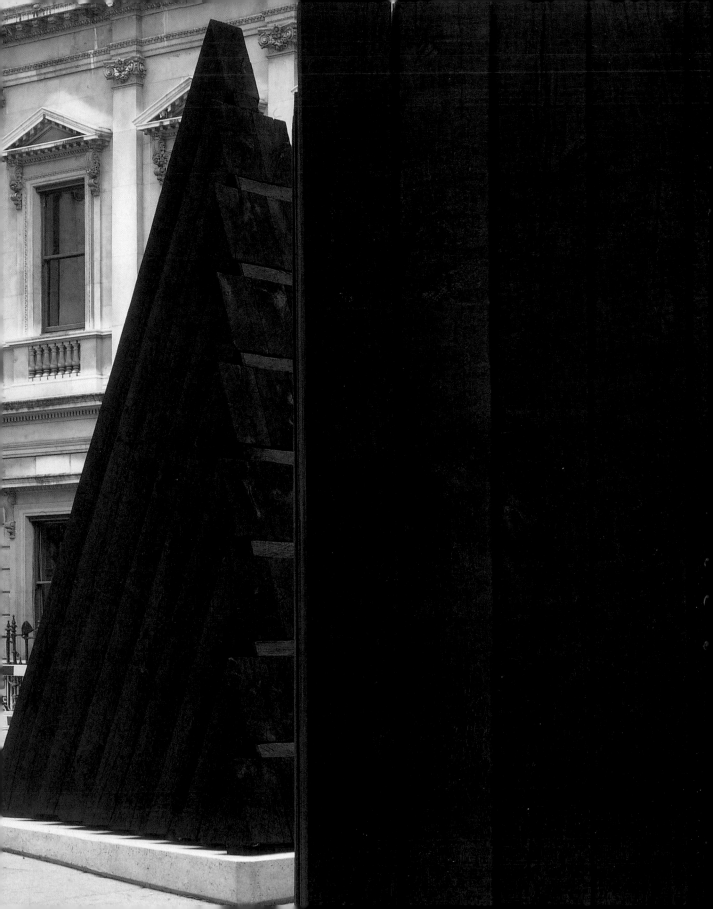

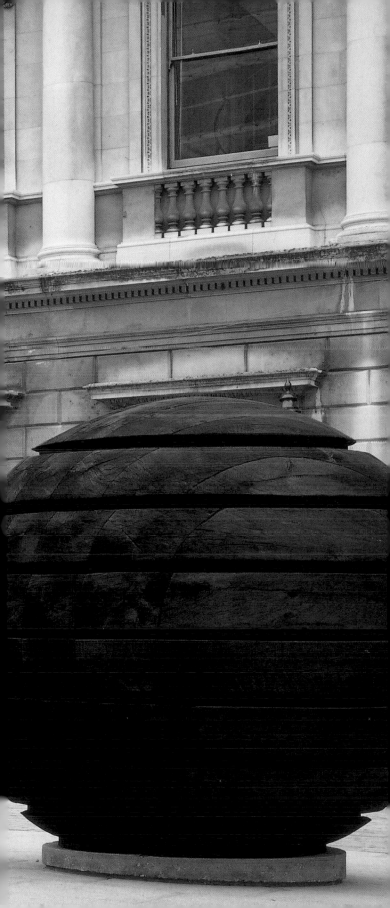

David Nash

Frank Whitford

It would be difficult for any sculpture to hold its own against the scaffolding and plastic sheeting now obscuring most of the learned and ornate façades in the Annenberg Courtyard of Burlington House, traditionally reserved for displays of imposing sculpture during the run of the Summer Exhibition. Somehow, though, David Nash's monumental and expressive treatment of the three primary solids – the pyramid, sphere and cube – in wood blackened by charring succeeds in asserting their identity in even these visually confusing surroundings.

The elemental nature of the forms themselves and their deep, black, light-absorbing surfaces command attention. They also intrigue the eye and mind thanks to the fundamental contrast between the basic geometry and the natural material from which they are made. Geometry is universal, and appeals to the mind. Wood, like art, is natural, organic and changeable; it appeals to the feelings. The human hand has transformed the ideal forms of what mathematicians know as the Pythagorean solids into imperfect carvings, the expression of states of mind. The objects have also been changed in another way. The charring of the oak – which comes from northern France from a tree blown over in the great storm of 1999 – has resulted in an actual, chemical change, at least on the surface, from a vegetable to a mineral (carbon) state.

There is yet another way in which these sculptures present a contrast. They diverge from the perfection of geometric norms. They are not the same size and shape from every angle. The sides of the pyramid are not equilateral triangles. Nor, indeed, is it a pyramid at all from some points of view. It is more of a ziggurat. The cube is similarly wayward with its unequal measurements, and its surface is, like that of the other forms, repeatedly interrupted by deep, regular cuts.

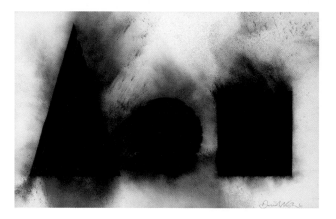

◄ *Pyramids Rise, Spheres Turn, and Cubes Stay Still*, 2002
Charred oak

Above: *Pyramids Rise, Spheres Turn, and Cubes Stay Still*
Charcoal on paper, 80 × 121 cm

Right: David Nash scorching the pyramid in the Annenberg Courtyard, May 2005

Nash uses these shapes repeatedly, both on a huge scale, as here, and on more domestic terms. The wood he uses for some is charred, while in others it is left natural. All these sculptures make it clear that they are concerned with much more than geometry. They belong to the tradition of which Mondrian was an important part. In other words, they use an apparently simple and straightforward pictorial language as the vehicle for feelings and ideas. Just as the horizontal and vertical possessed a philosophical dimension for Mondrian, these fundamental forms hold a specific meaning for Nash. As he recently put it:

> The sense of the Cube
> is solid unmoving
> representing Matter

> The sense of the Sphere
> is one of movement turning
> representing Time

> The sense of the Pyramid
> is rising expanding
> representing Space

Nash, elected an RA in 1999, was born in 1945 in Esher, Surrey. Widely regarded as one of the leading middle–generation British sculptors, he can look back on a career of more than thirty–five years. For all that time, with remarkable consistency, he has made sculpture that explores the relationship between man and nature, and exploits the contrast between the organic and the man–made.

Perhaps because he originally came from the lush, leafy stockbroker belt of Southern England, Nash chose to live elsewhere. For almost forty years he has been based in a remote part of North Wales, in a redundant chapel called Capel Rhiw, close to the tips from slate quarries near Blaenau Ffestiniog, which somehow dramatise an already romantic landscape. Then as now he uses unseasoned timber from hardwood trees – he's not fond of the graining of evergreens – as his sole material, and he cuts rather than carves it. His tools are chainsaws rather than chisels. The forms he creates are always primary, universal shapes, or approximations of them. As he said in 2004 in an interview, 'It's the poetry and geometry of movement that interest me. When we think of geometry, we don't think of movement. These are universal forms, they don't belong to anyone. For me it represents a human order, a process of understanding. Geometry represents an order in nature or a path for me. Like my line of cut.'

Indeed, Nash's forms are frequently cut into and, like those in the Annenberg Courtyard, always cut in the same way: horizontal for the sphere, vertical for the cube and diagonal for the pyramid. Then, frequently, burners are used to scorch the wood, to transform its surfaces through blackening. In the same interview Nash explained how the charring emphasises an important difference between wood and stone: 'When I see a sculpture made of wood, the first thing I see is the wood and then I see the form; if it's burnt it is no longer an experience connected with the emotional narrative of living wood. It also changes the sense of time. The feeling of time in wood is quite close to ours in terms of our sense of mortality… compared to stone, wood is closer to us and I think we have a natural affinity with it and understand that it has a defined mortality. We don't feel the mortality of stone.' Stone seems somehow more permanent – even when it needs to be cleaned and restored, as it does now in the Annenberg Courtyard.

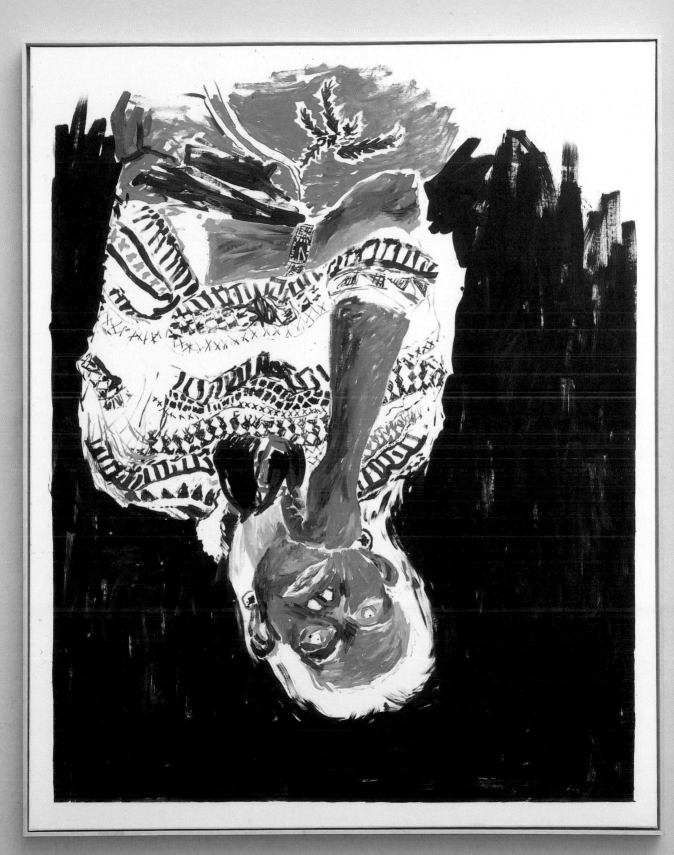

Mimmo Paladino HON RA
Miraggio IV
Etching and aquatint
38 × 50 cm

Frank Stella HON RA
Stubb and Flask Kill a Right Whale (Dome)
Mixed media
190 × 136 cm

A.P. IV F Stella '94

Ellsworth Kelly HON RA
State of 'The River' 2005
Suite of eight lithographs on Arches cover
101 × 81 cm (overall size: 119 × 721 cm)

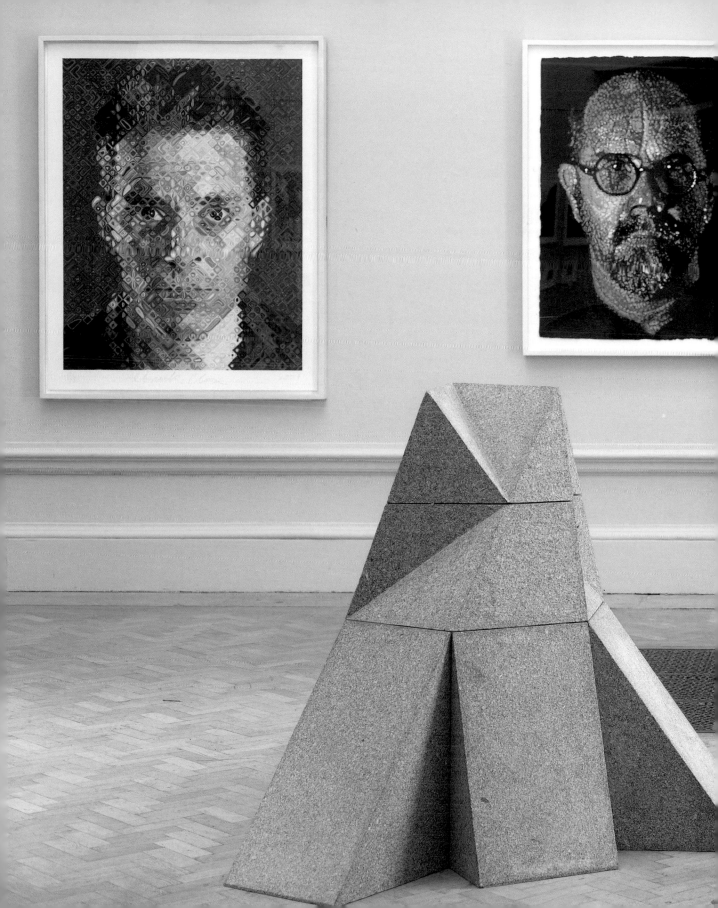

Helen Frankenthaler
Snow Pines
Ukiyo–e woodcut
94 × 66 cm

Helen Frankenthaler
Geisha
Ukiyo-e woodcut
94 × 66 cm

Dan Rizzie
William Morris
Etching and aquatint
50 × 38 cm

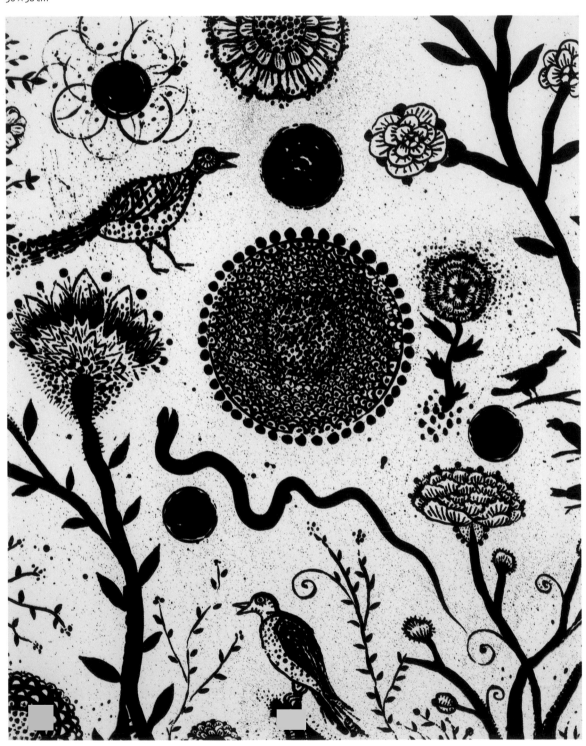

Louise Bourgeois
Male and Female (diptych)
Drypoint
35 × 25 cm

 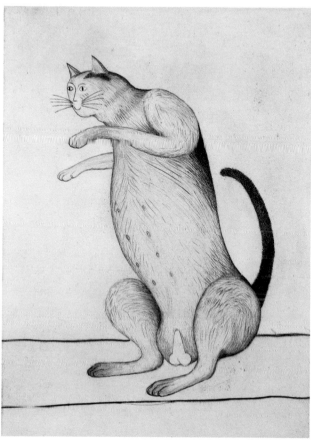

James Siena
Set of 5 (Recursive Combs – Vertical; Double Recursive Combs – Horizontal; Two Floppy Combs; Floppy Recursive Combs; Heliopolis)
Wood engraving
30 × 25 cm each

Joel Shapiro
Untitled A–E
Woodcut
66 × 48 cm each

Lucian Freud
Painter's Garden
Etching
64 × 86 cm

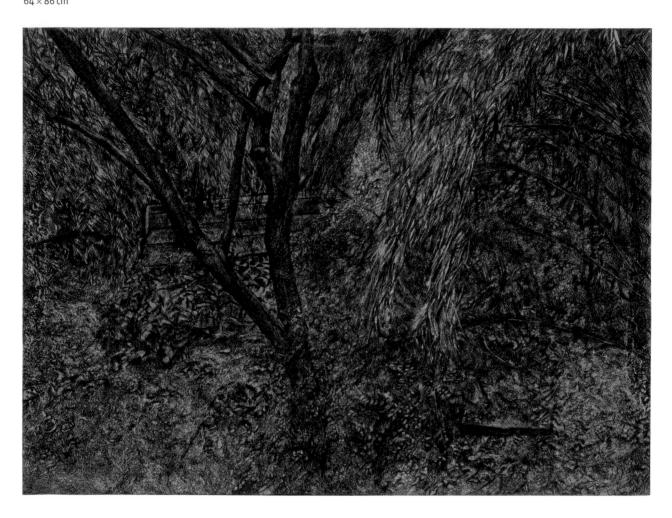

April Gornik
Silhouetted Trees
Etching
83 × 64 cm

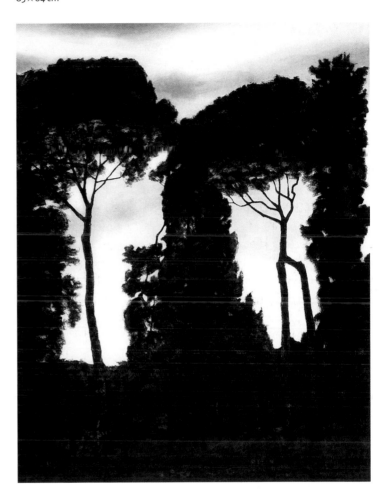

James Rosenquist
The Stowaway Peers Out at the Speed of Light
Lithograph
117 × 268 cm

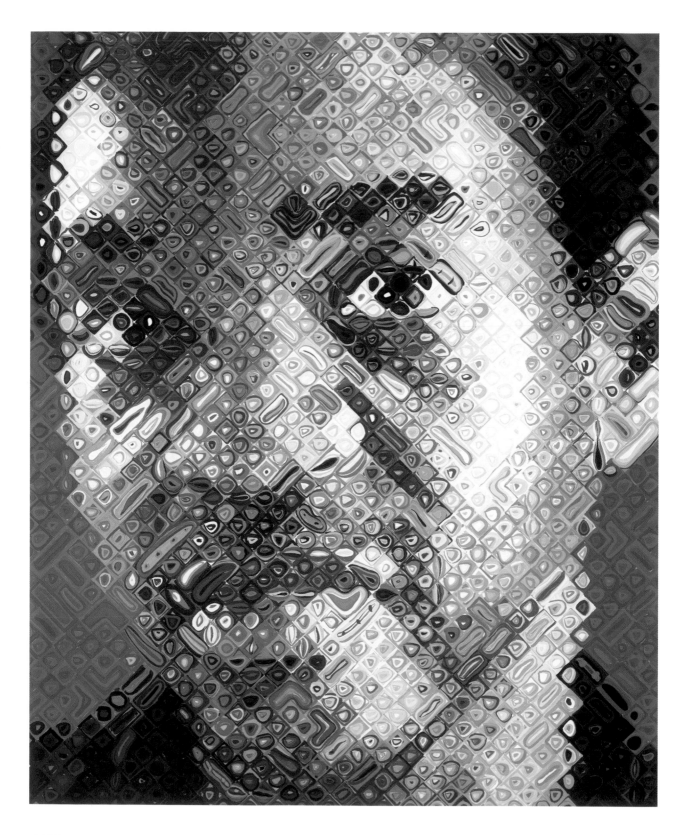

Chuck Close
Lyle
Silkscreen
166 × 136 cm

Avigdor Arikha
Anne with Fur Hat
Drypoint
20 × 26 cm

LARGE
WESTON
ROOM

The Late Prof Sir Eduardo Paolozzi CBE RA
Calcium Light Night III, Central Park in the Dark Some Forty Years On, 1974–76
Screenprint
80 × 50 cm

Prof Gary Hume RA
Succulent
Screen print on aluminium
84 × 43 cm

Ljim Haldane
Bucket
Etching
32 × 24 cm

Glen Baxter
The English Twins
Etching
33 × 24 cm

Prof Phillip King CBE PPRA
Oiseauleurs
Giclée print
20 × 28 cm

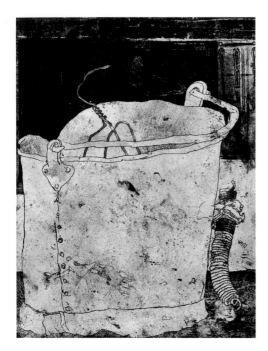

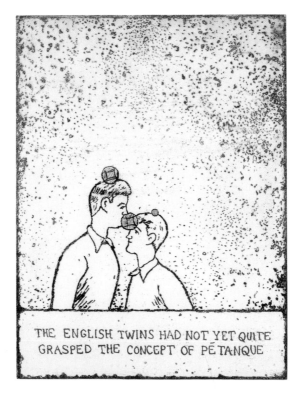

Prof Chris Orr RA
Santiago or Bust!
Silkscreen
90 × 130 cm

Gillian Ayres OBE RA
Finnegan's Lake
Etching and aquatint
46 × 56 cm

Albert Irvin RA
Tabard
Screenprint and woodblock
60 × 79 cm

Stephen Farthing RA
Washington, Crossing the Frozen Delaware no. 3
Etching
39 × 97 cm

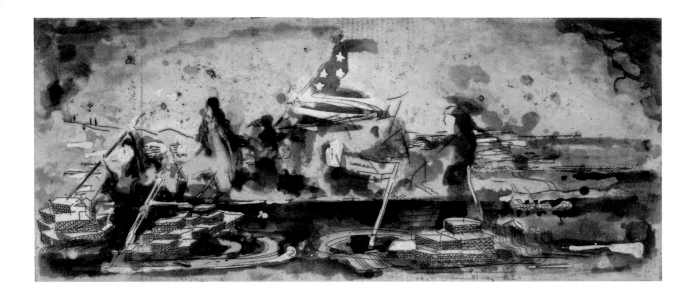

Antoni Tàpies HON RA
RA
Aquatint
101 × 67 cm

Stephen Conroy
The Man Who Drew Too Much
Etching
26 × 20 cm

Freya Payne
The Ghosts of My Desire
Etching
30 × 29 cm

Leonard McComb RA
Gemma Quintana
Etching
44 × 33 cm

Craigie Aitchison CBE RA
Tree and Poppy Montecastelli
Screenprint
16 × 12 cm

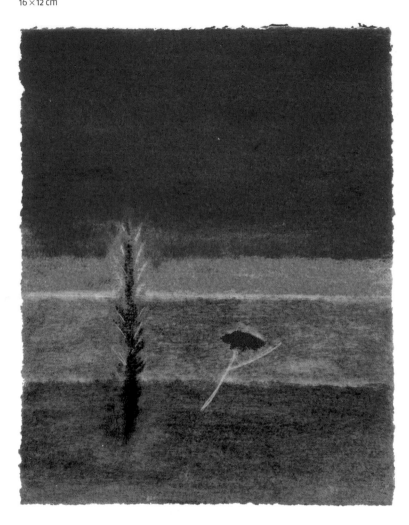

Sasa Marinkov
In Shadow
Linocut
38 × 55 cm

Francis Tinsley
The Barracuda on Its Way to Haiphong to Be Broken Up
Woodcut and screenprint
45 × 64 cm

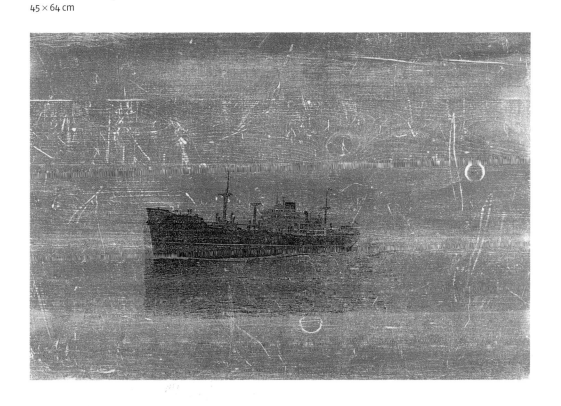

Peter Freeth RA
In a Faraway Country of Which We Know Little
Aquatint
67 × 54 cm

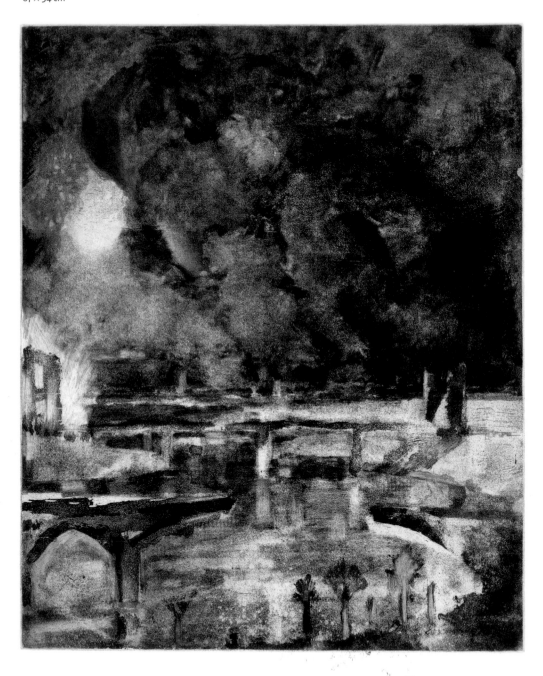

Richard Hamilton
Ghosts of UFA
Lithograph
55 × 68 cm

Meg Dutton
Cat on a Mat
Etching and watercolour
15 × 20 cm

Chris Plowman
Work Horse
Etching
40 × 60 cm

Lori Solondz
Accablé
Etching
10 × 7 cm

Susie Perring
Life in the Old Dog Yet
Aquatint etching
12 × 12 cm

Ray Richardson
MFSB
Screenprint
10 × 33 cm

Biljana Tesic
By Leaps and Bounds…
Photoetching
16 × 12 cm

Christopher Brown
Little Dog
Linocut
6 × 6 cm

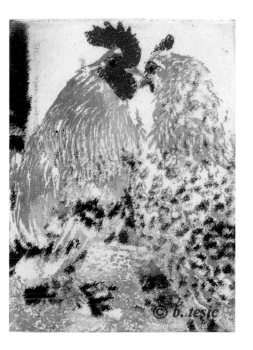

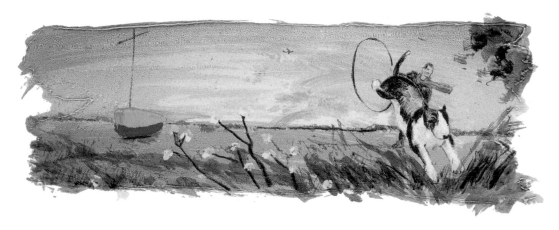

John Gledhill
Steam Train
Linocut
31 × 37 cm

Bill Pryde
Fukinagashi
Screenprint
21 × 21 cm

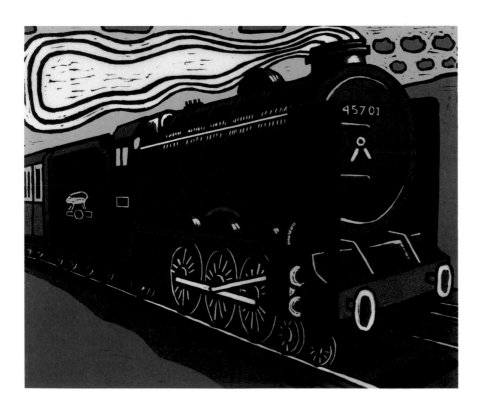

Kevin O'Keefe
Twentieth–Century Cow
Inkjet
30 × 30 cm

Tom Piper
Always Arrangements 2
Digital inkjet
28 × 28 cm

Dr Jennifer Dickson RA
Silver Streams (The Lily Terrace, Bodnant)
Giclée print
40 × 25 cm

Bill Jacklin RA
Ponte degli Ombrelli VI
Etching
75 × 57 cm

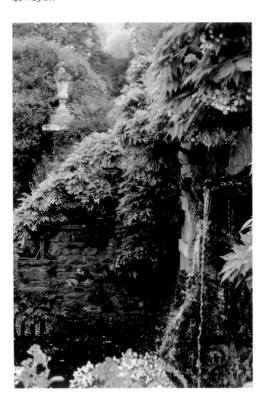

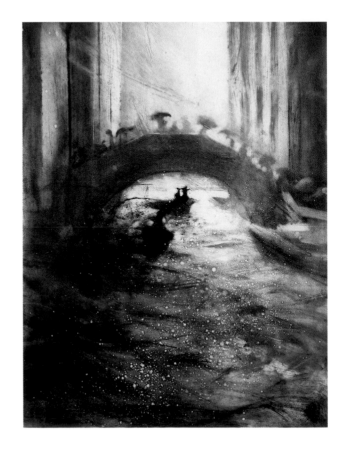

Dr Barbara Rae CBE RA
Broadhaven
Screenprint
93 × 93 cm

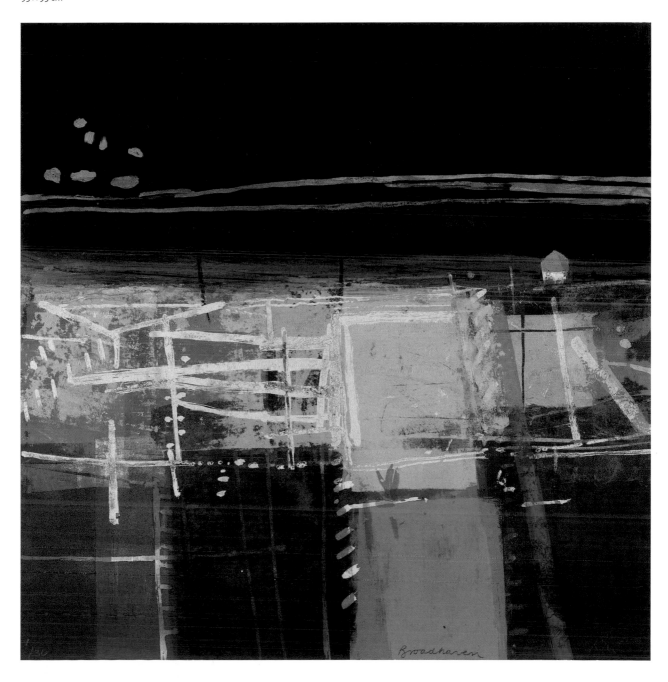

Anthony Green RA
Patisserie
Giclée print
68 × 68 cm

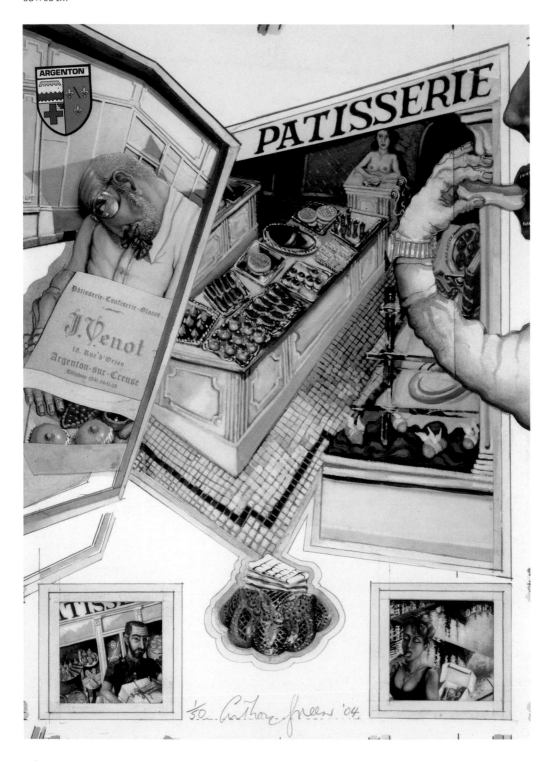

Paula Rego
Life Room
Lithograph
38 × 36 cm

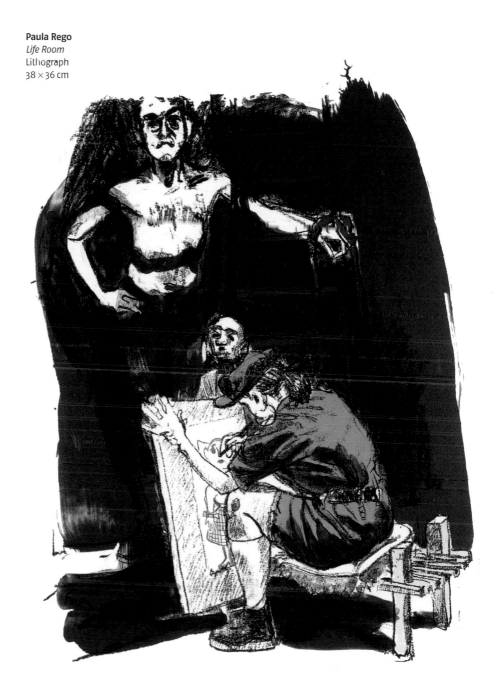

Celia Paul
Post Office Tower
Etching
18 × 7 cm

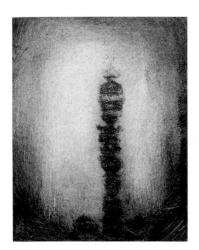

Irmgard Parth
Das Kar
Woodcut
48 × 28 cm

Prof Norman Ackroyd RA
Little Brancaster
Etching
10 × 21 cm

Andrzej Klimowski
Piazza
Linocut
30 × 40 cm

Stephen Chambers
Shack Life
Etching
49 × 53 cm

SMALL
WESTON
ROOM

Tony Snowden
New Street
Oil
51 × 38 cm

Bridget Moore
Bedside Lamp
Gouache
23 × 24 cm

Pamela Kay
Pewter Dish of Redcurrants
Oil
28 × 22 cm

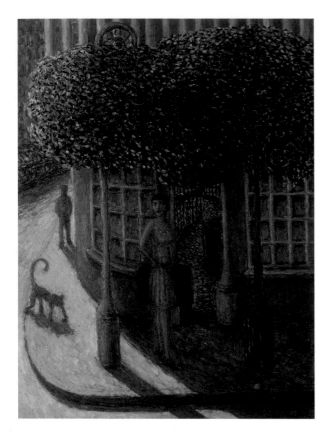

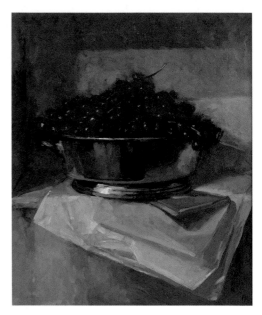

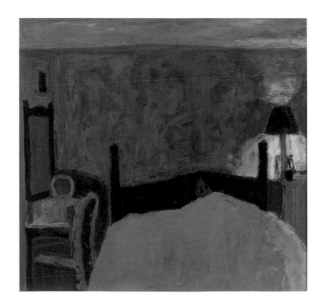

Michael Collins
Newport
Pencil
29 × 39 cm

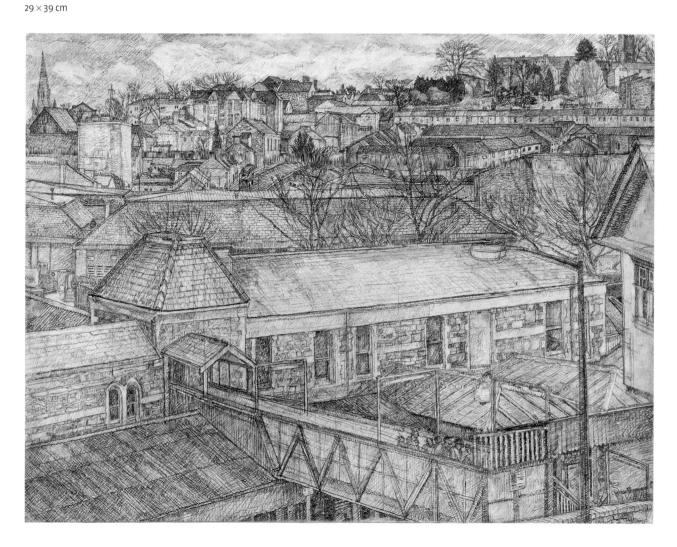

Jane Dowling
Beach Study, Sizewell
Egg tempera
33 × 55 cm

Diana Armfield RA
Corner of a Sunflower Field, St Félix
Chalk
18 × 26 cm

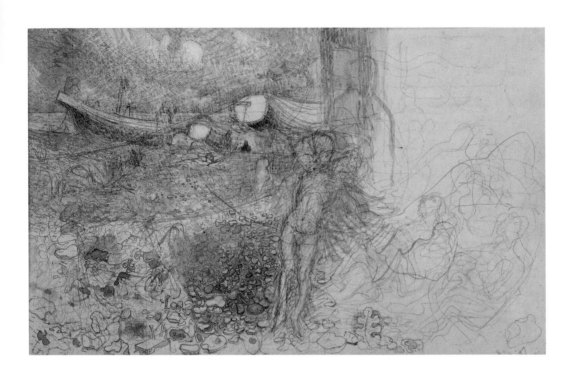

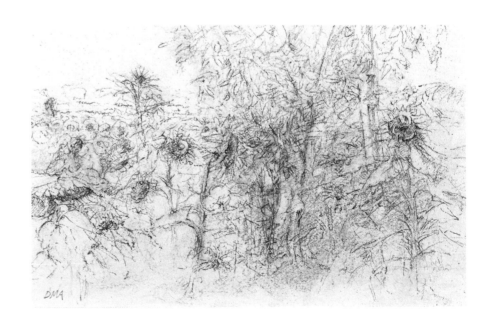

Liz Bailey
On the Road, Spain 6
Oil
15 × 30 cm

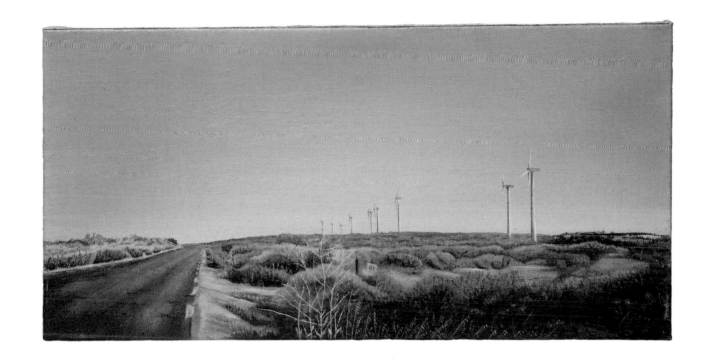

Bernard Dunstan RA
The Rehearsal
Oil
28 × 29 cm

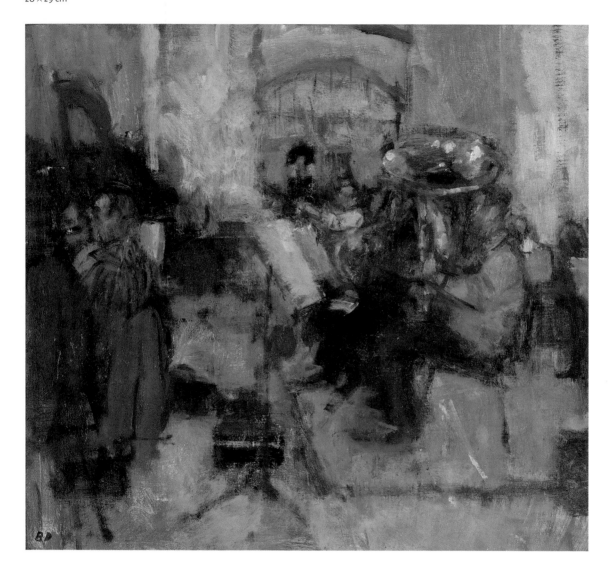

Mick Rooney RA
Private Garden (Spain)
Oil
50 × 39 cm

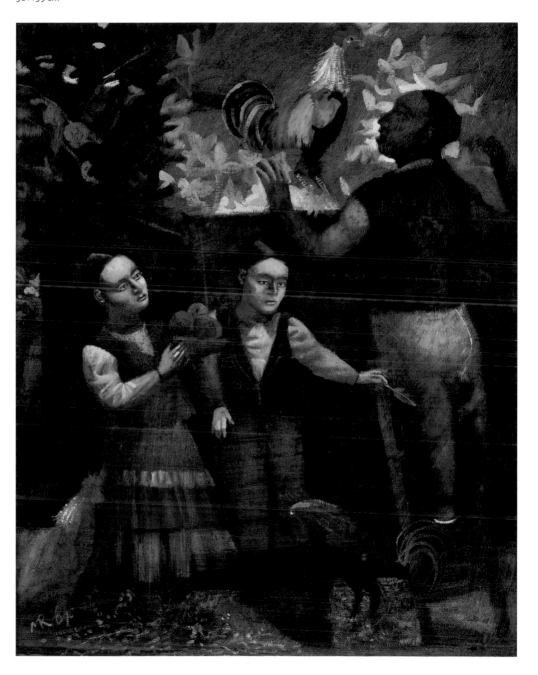

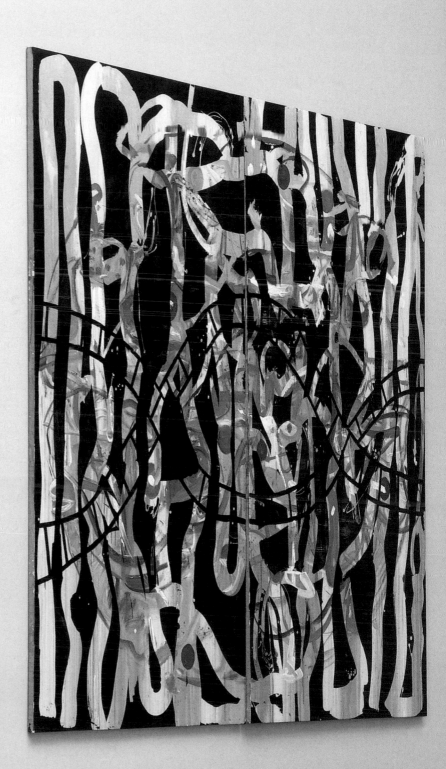

Prof Paul Huxley RA
Rang
Acrylic
173 × 173 cm

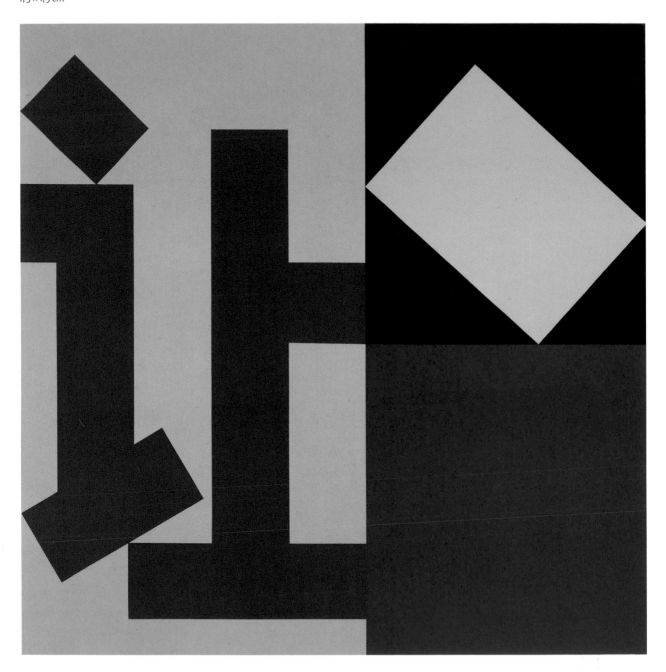

Dr John Bellany CBE RA
The Bundt, Shanghai, China
Oil
90 × 120 cm

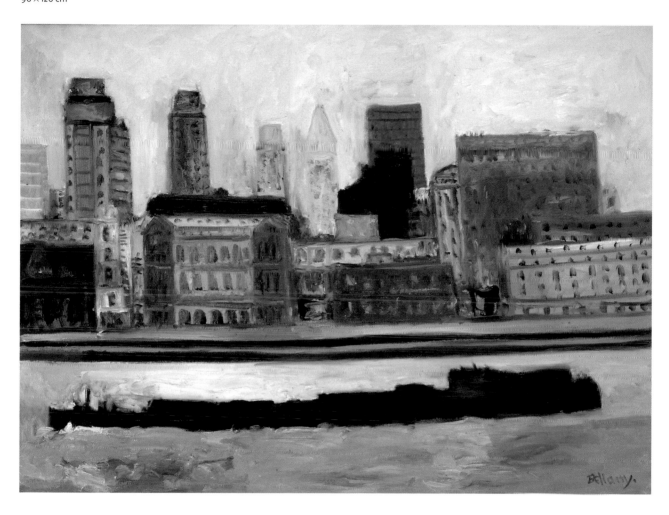

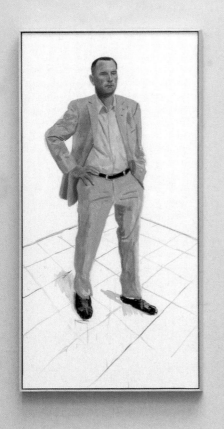
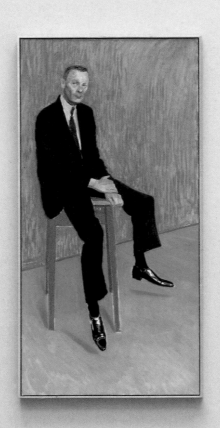
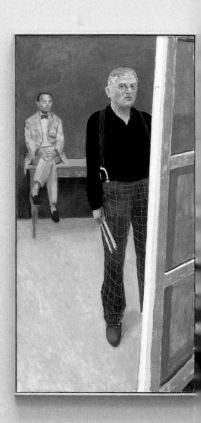

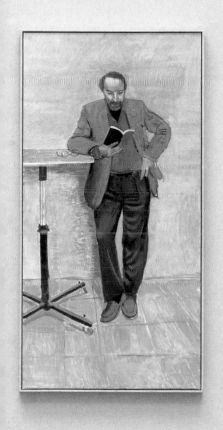
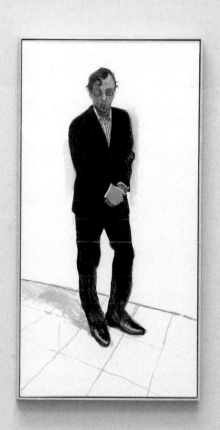
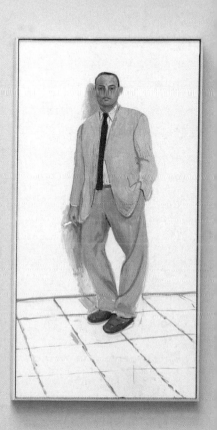

David Hockney CH RA
Left to right: *Richard Schmidt*;
Arthur Lambert; *Self-portrait
with Charlie*; *Lawrence Weschler*;
Gregory; *Charlie Scheips*
Oil
182 × 91 cm each

Maurice Cockrill RA
Pathology – Magnus I
Oil and acrylic
300 × 400 cm

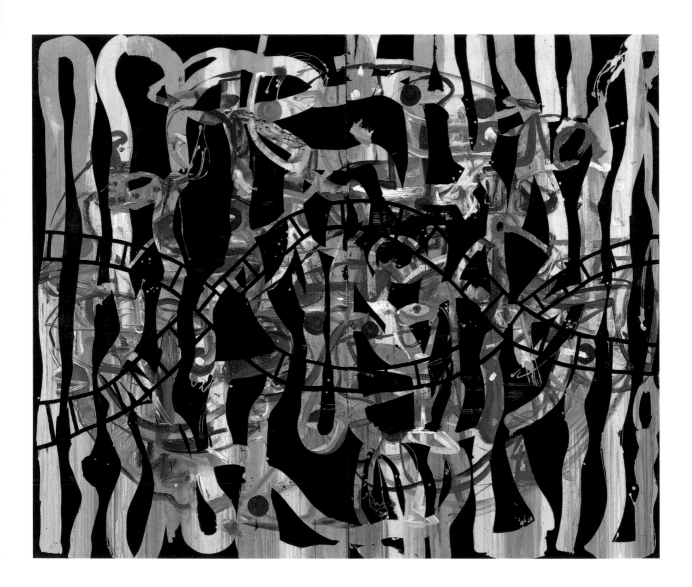

Eileen Cooper RA
Get in on the Act
Oil
122 × 153 cm

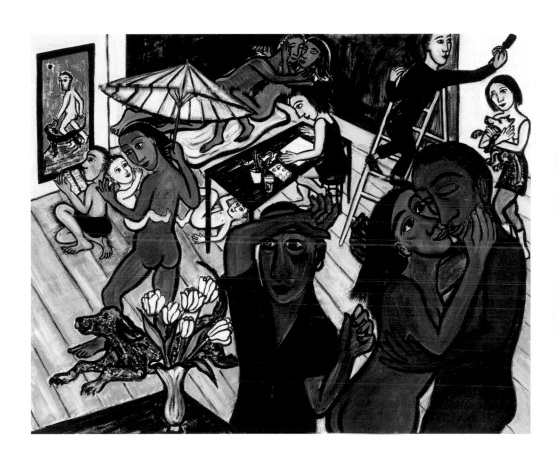

Flavia Irwin RA
Shadow Mark 2
Acrylic and pencil
88 × 68 cm

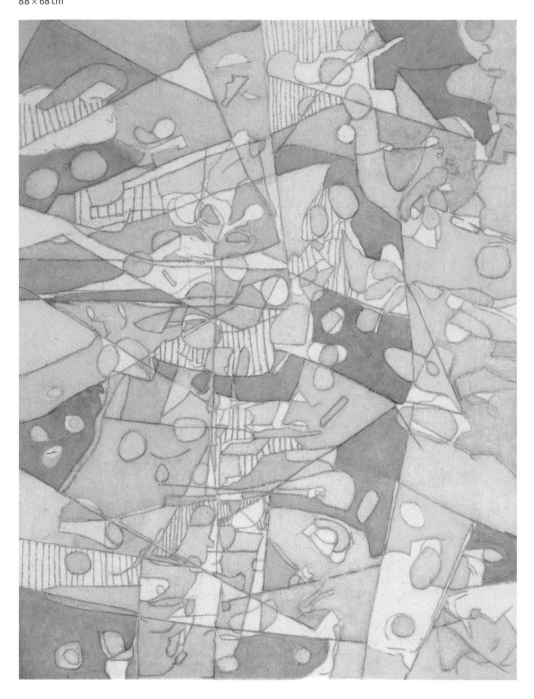

Mick Moon RA
Megna
Mixed media
61 × 61 cm

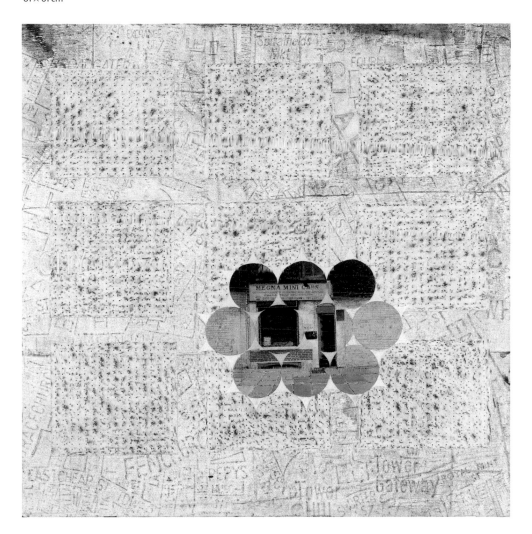

Joe Tilson RA
Conjunction, Tiger Moth, Seme (from Conjunctions)
Screenprint
54 × 76 cm

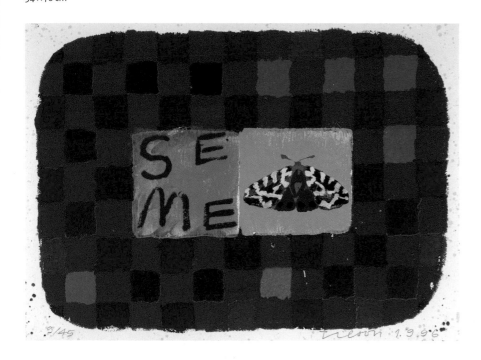

Prof John Hoyland RA
The Path of Love 8.3.2004
Acrylic
235 × 255 cm

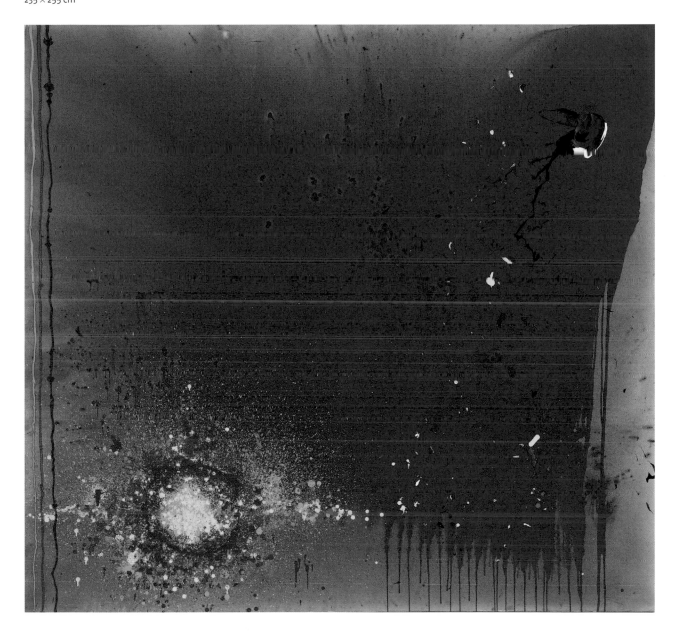

Ian McKeever RA
Four Quartets, Here
Oil and acrylic
220 × 360 cm

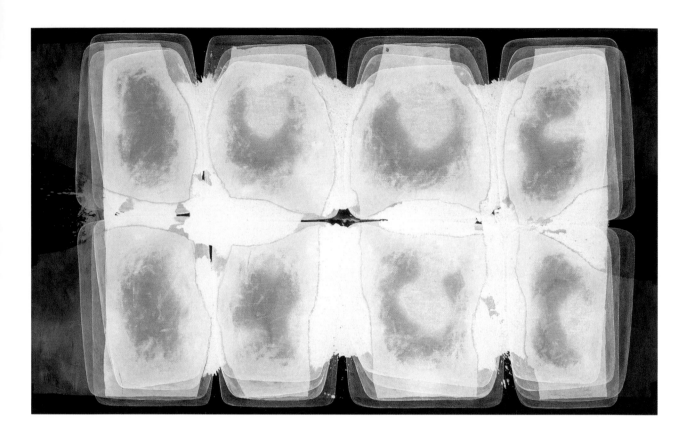

Anthony Whishaw RA
Pond VII 2004/05
Mixed media
212 × 228 cm

R. B. Kitaj RA
Lot and His Daughters (after Cézanne)
Oil
92 × 90 cm

Humphrey Ocean RA
The Passing Show
Oil
190 × 248 cm

IV

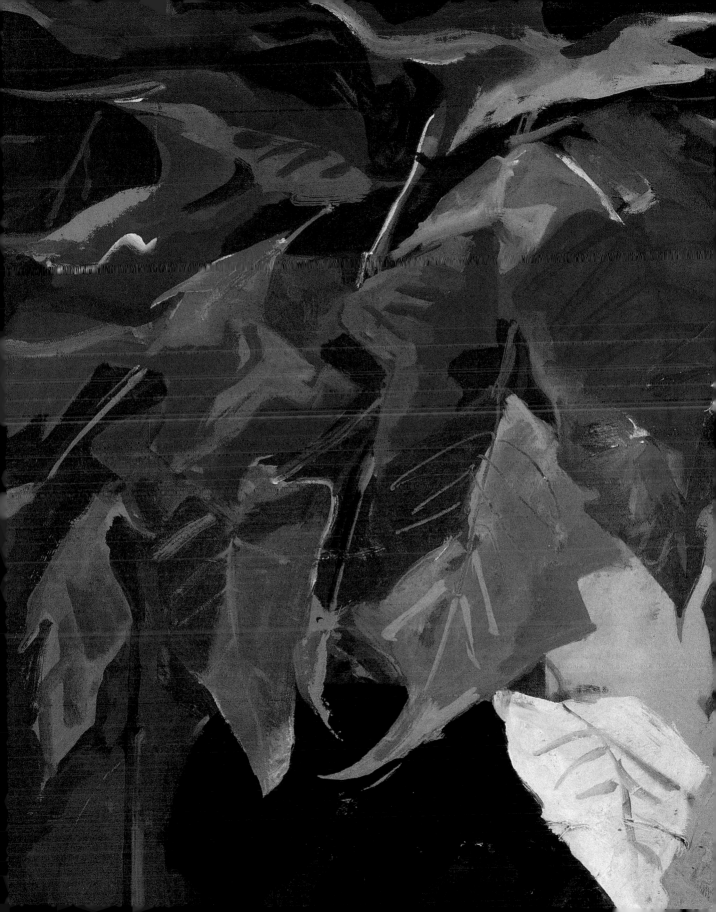

Jean Cooke RA
Fancy a Swim?
Acrylic
67 × 61 cm

Frederick Gore CBE RA
From the Piccadilly Hotel, New York: Dusk, Traffic and Demolitions
Oil
120 × 90 cm

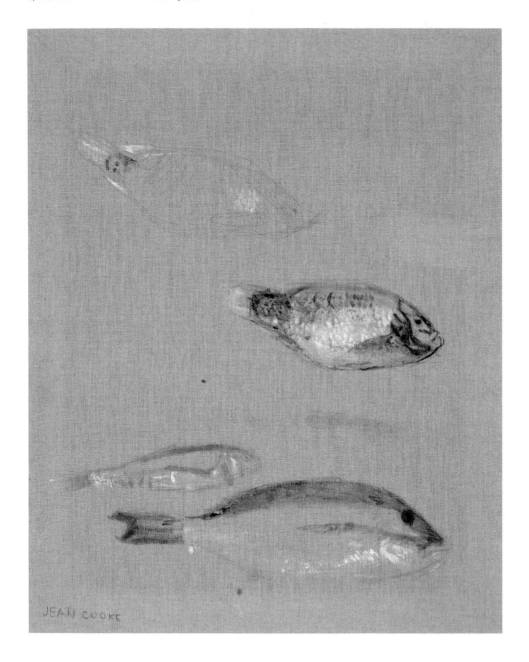

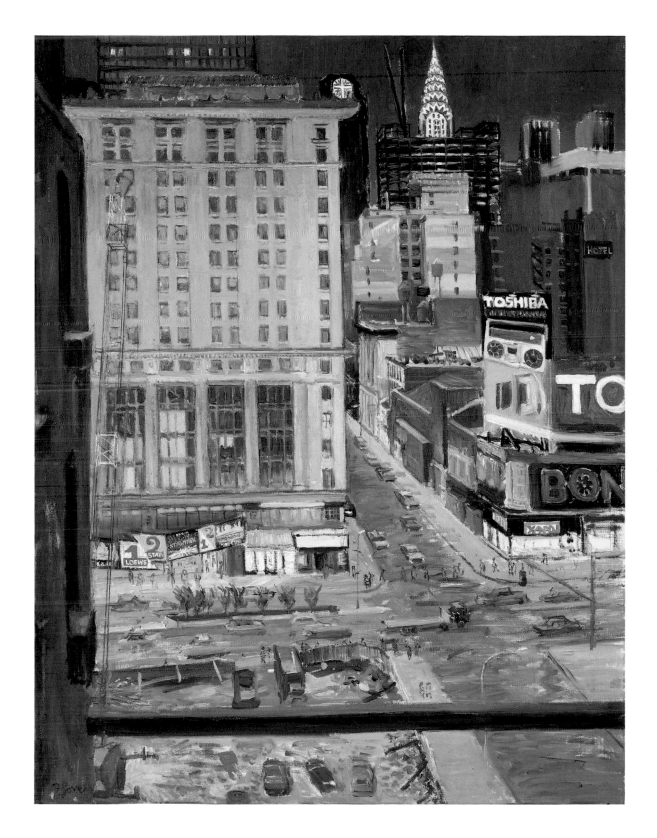

Ken Howard RA
Self–portrait with Borsalino
Oil
122 × 160 cm

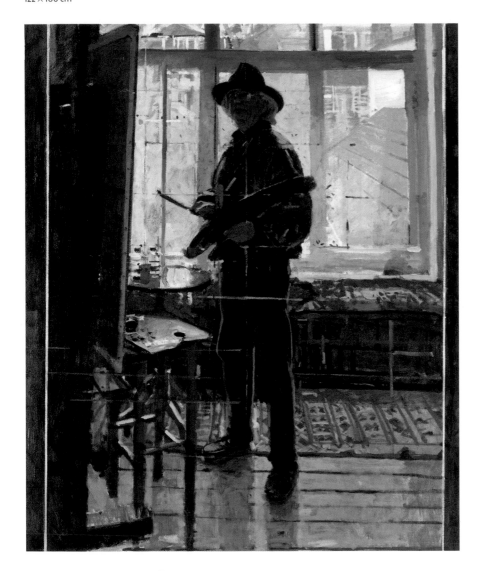

Dame Elizabeth Blackadder DBE RA
Still-life with Mirror and Japanese Print
Oil
120 × 120 cm

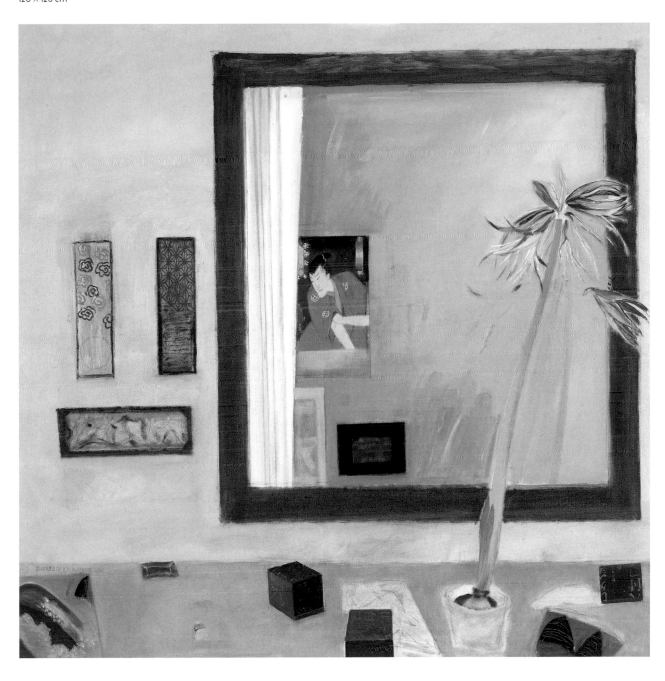

The Late Peter Coker RA
The Grand Staircase, Clos du Peyronnet, late afternoon
Oil
115 × 146 cm

Mary Fedden OBE RA
Boxing Day
Oil
80 × 90 cm

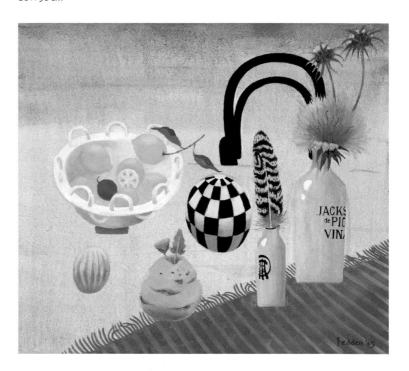

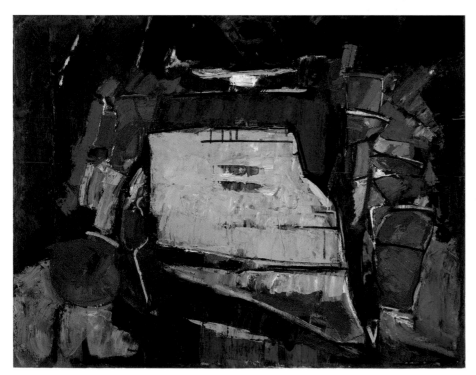

Ben Levene RA
Storm over the Wye Valley
Oil
34 × 38 cm

William Bowyer RA
Crab Fishermen at Walberswick
Oil
70 × 79 cm

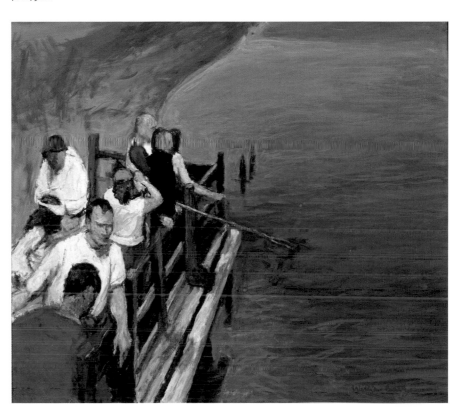

Philip Sutton RA
Magnificent!
Oil
108 × 140 cm

Meg Dutton
Mosques and Minarets
Etching
76 × 41 cm

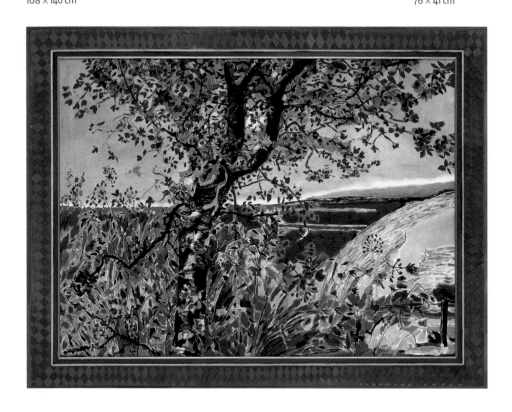

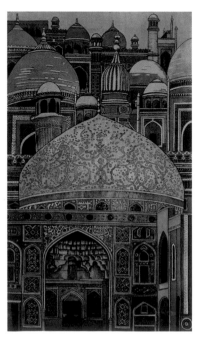

Donald Hamilton Fraser RA
Poinsettia
Oil
118 × 87 cm

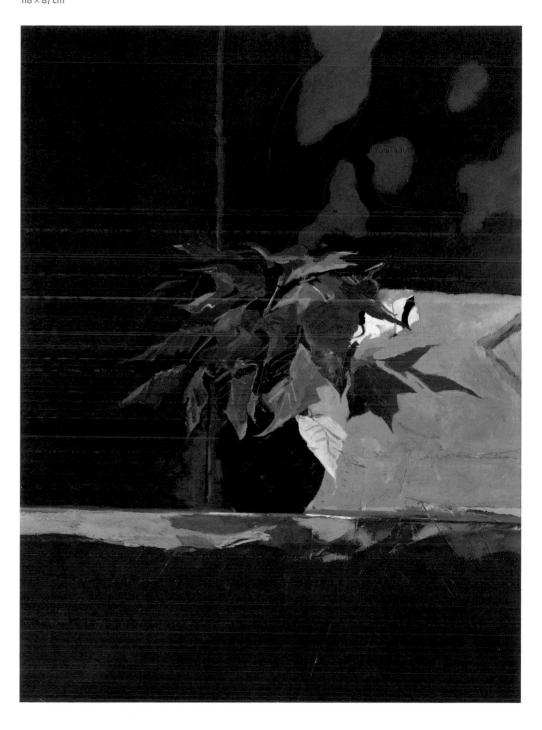

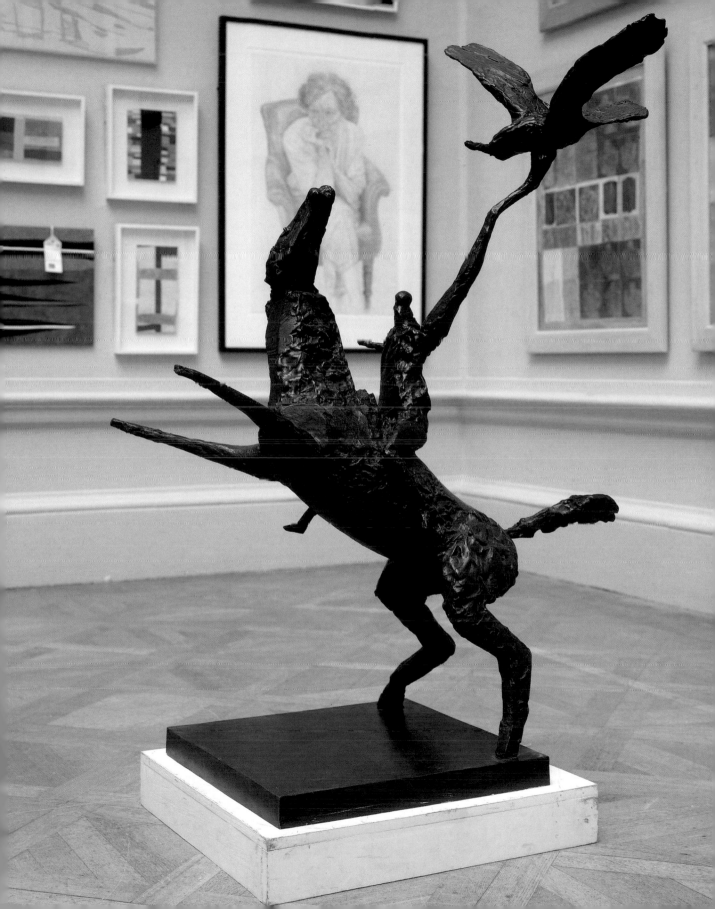

David Tindle RA
Siesta
Egg tempera
105 × 82 cm

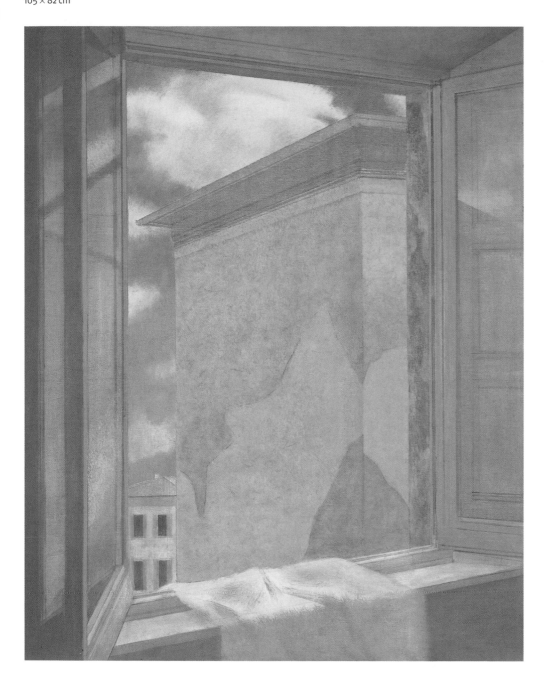

Sonia Lawson RA
River Shallows
Oil
121 × 152 cm

Christopher Le Brun RA
Tower with Road and Figures
Watercolour
58 × 75 cm

Jennifer Durrant RA
From a Series 'Uccelli'
Acrylic
34 × 16 cm

Anthony Eyton RA
Varinas
Pastel
85 × 165 cm

Frederick Cuming RA
The Wave, Golden Cap, Dorset
Oil
90 × 90 cm

Carey Clarke
Elegy for our Time (detail)
Oil
108 × 164 cm

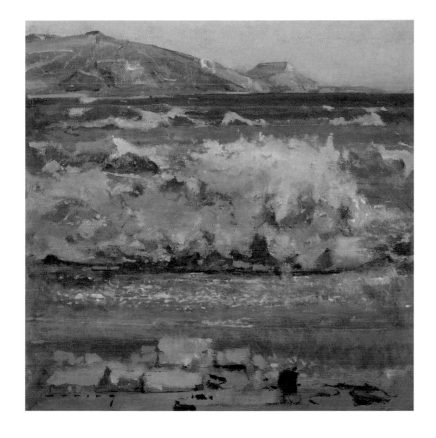

Olwyn Bowey RA
Corncobs
Oil
88 × 97 cm

The Late Norman Adams RA
Phaeton Passes
Watercolour
181 × 156 cm

VI

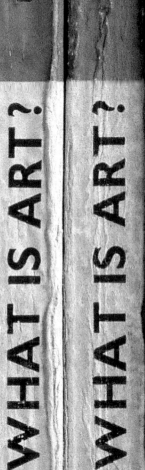
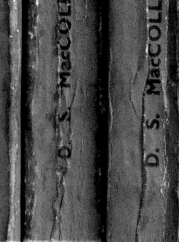

Stephen Walter
Affordable Houseton
Pencil
66 × 92 cm

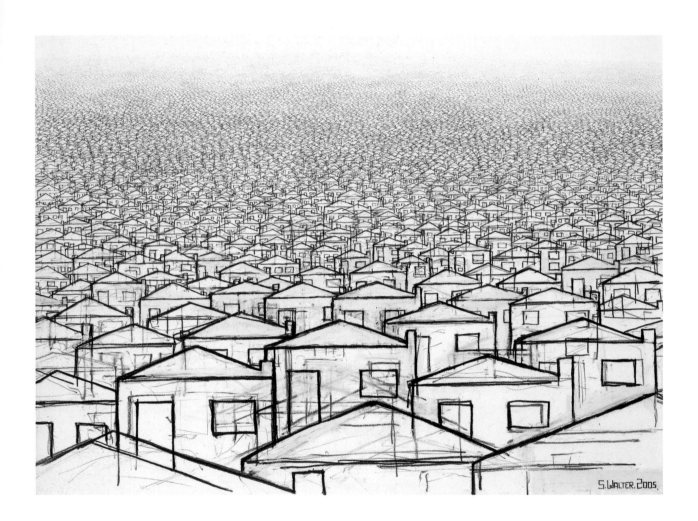

Sarah Staton
Post Pop Hamburger
Bronze
16 × 23 cm

Langlands & Bell
WWW
Laser–etched crystal
10 × 10 cm

Grenville Davey
Little Emperor
Aluminium
H 36 cm

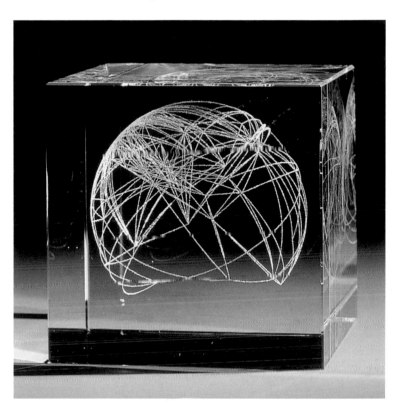

Tom Phillips CBE RA
If I've told you once
Books (Pelican Classics)
H 11 cm

William Barnet
Woman Reading
Silkscreen
89 × 60 cm

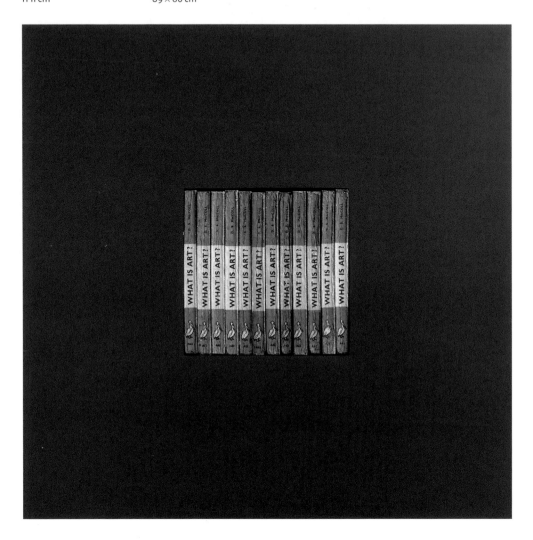

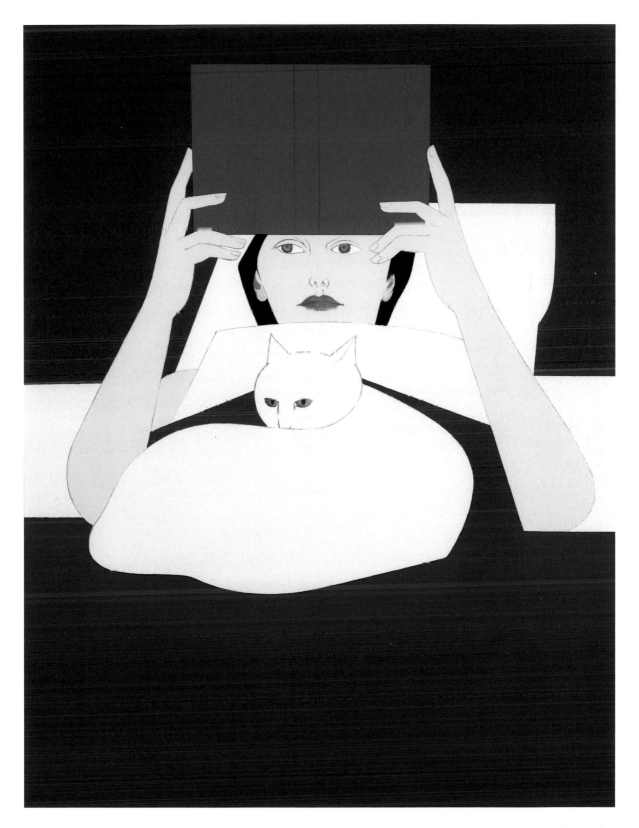

Dan Hays
Sanctuary
Mixed media
46 × 68 cm

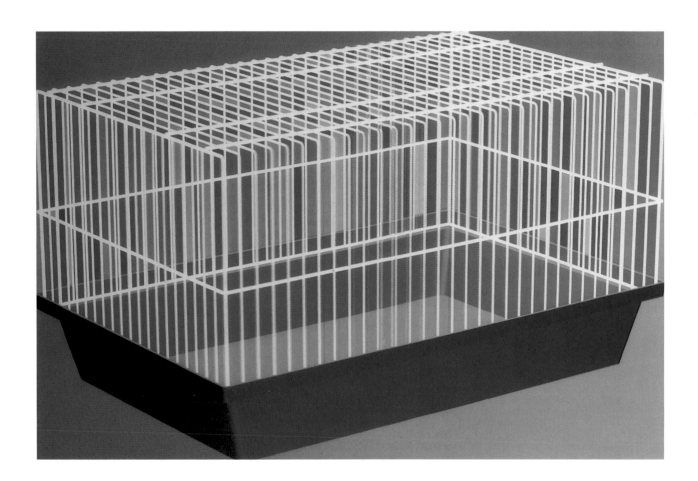

Lisa Milroy
Three White Plates with Gold Trim
Oil
80 × 26 cm

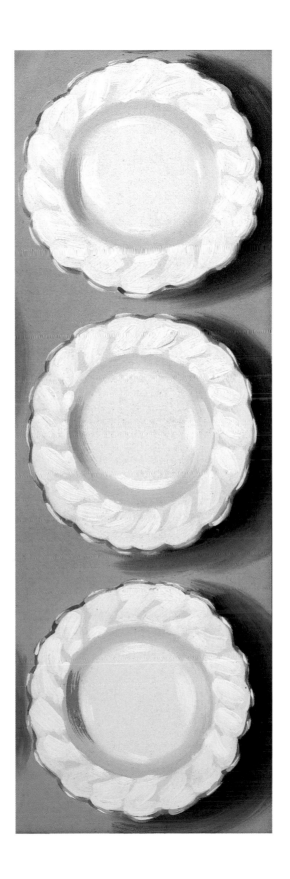

Langlands & Bell
Ruined Palace, Dar ul Aman
Print
58 × 80 cm

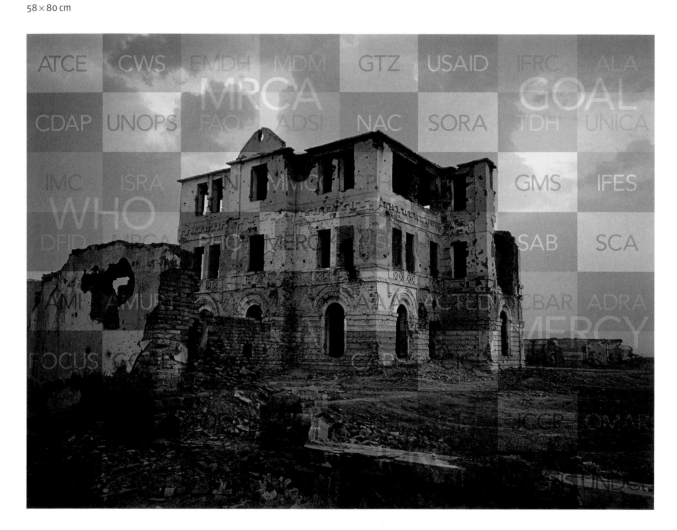

Adam Dant
Academy for the Improvement of the French Language (detail)
Relief print
125 × 117 cm

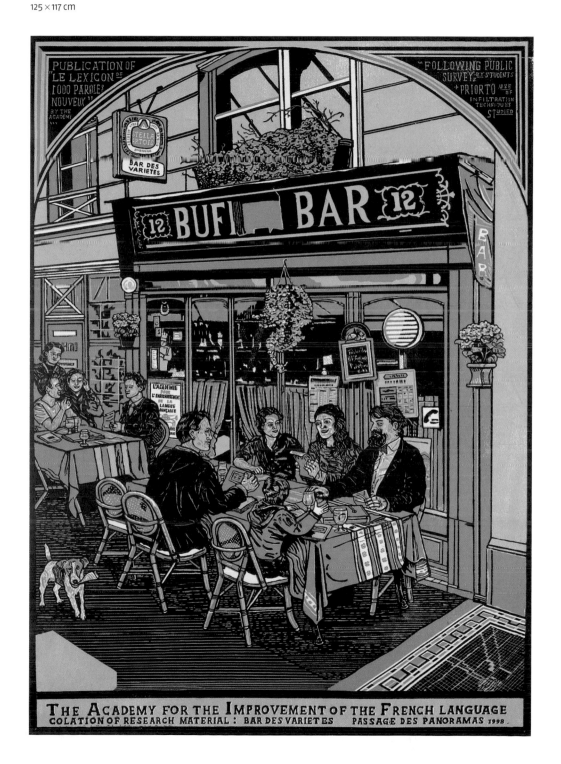

299,792

408 m/s

Cerith Wyn Evans
299,792,458 m/s
Neon
H 9 cm

Julian Opie
Winter Landscape
Screenprint
30 × 65 cm

Andreas Gursky
Untitled X (Constable)
Mixed media
226 × 163 cm

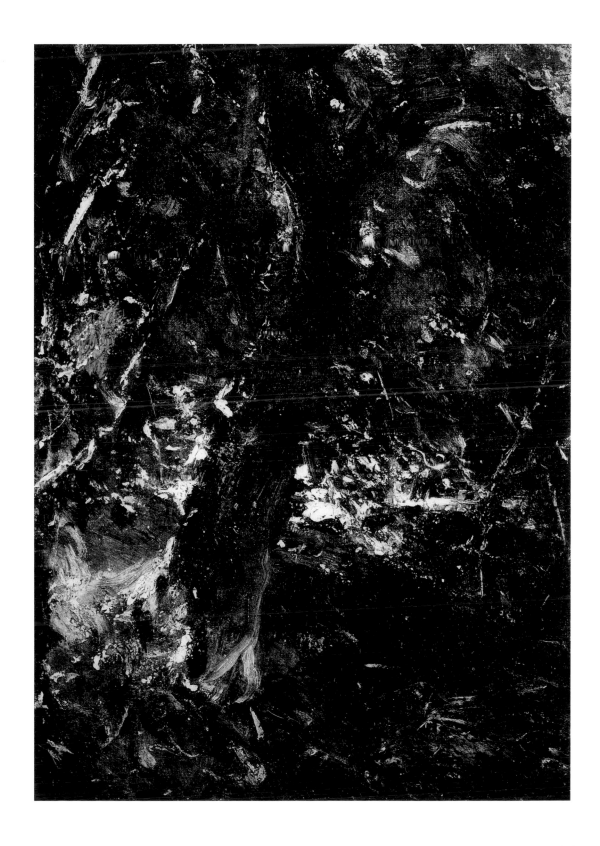

Alessandro Gallo
La Lettera
Silkscreen
58 × 79 cm

Jake and Dinos Chapman
Unhappy Meal
Etching
56 × 76 cm

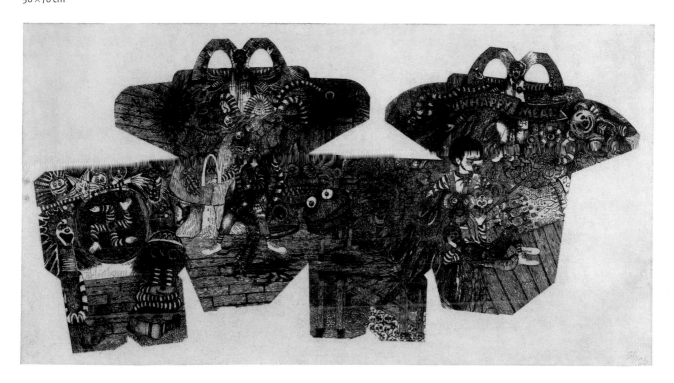

Michael Craig-Martin
Deconstructing Seurat (blue)
Screenprints
63 × 93 cm each

Gavin Turk
Diamond Yellow Elvis (working title)
Silkscreen ink on acrylic canvas
129 × 93 cm

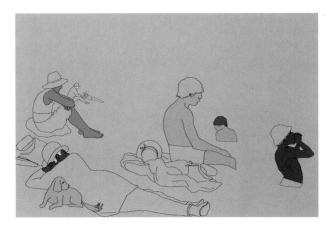

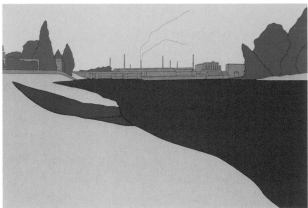

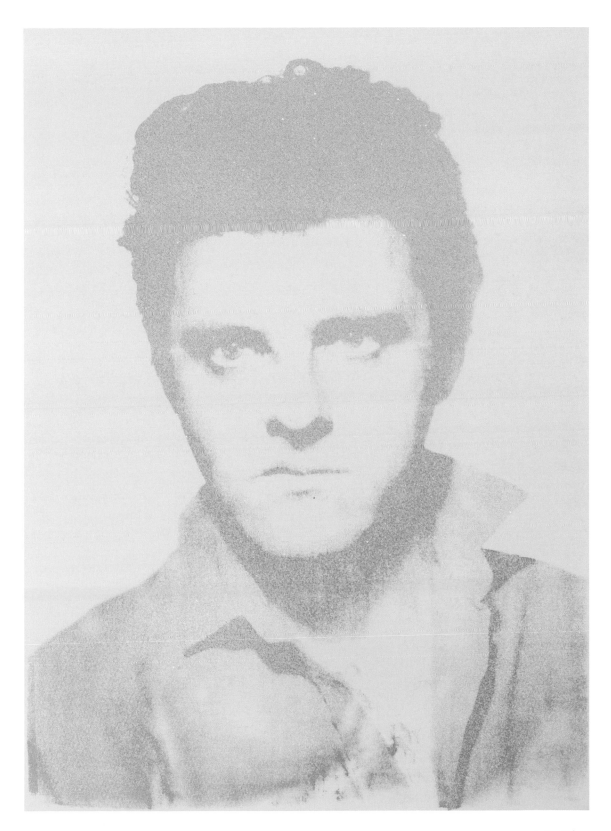

VII

Richard Long RA
Parnassus Line
Photograph
47 × 70 cm

PARNASSUS LINE

A SIX DAY WALK IN GREECE 2002

Alison Wilding RA
Rising
Cast acrylic and pigment
H 16 cm

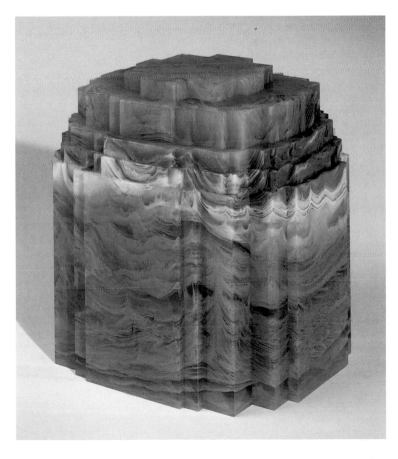

Prof Bryan Kneale RA
Fallen Tree
Conté
50 × 65 cm

Nigel Hall RA
Drawing no. 1062
Gouache and charcoal
67 × 67 cm

Cathy de Monchaux
Sweetly the Air Flew Overhead – Battle no. 4 (detail)
Mixed media
32 × 80 cm

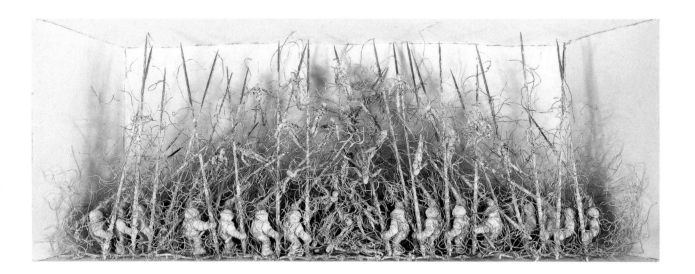

Prof Michael Sandle RA
WWI Ghosts Suite (II)
Aquatint
38 × 47 cm

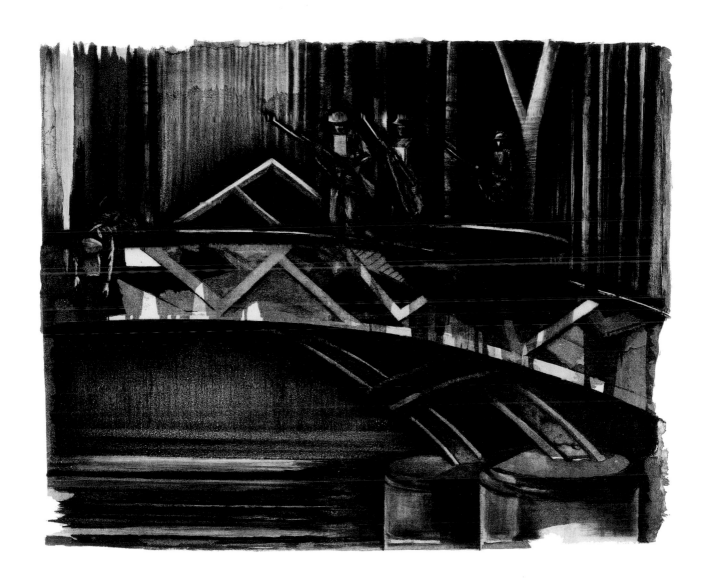

Marilène Oliver
Sophie
Silkscreen on acrylic
H 192 cm

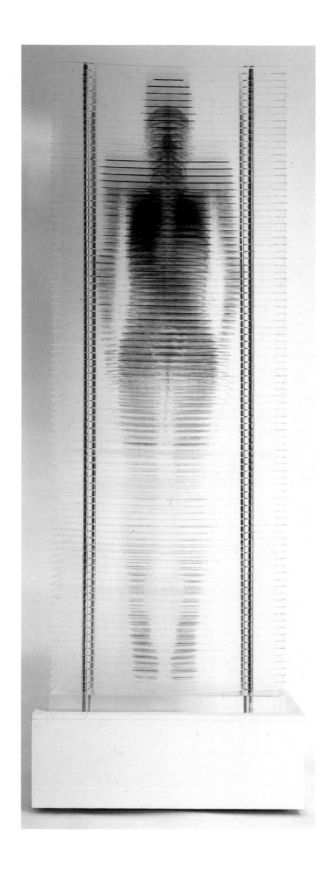

Ann Christopher RA
The Power of Place – 5
Mixed media
36 × 36 cm

John Maine RA
British Museum 250th Anniversary Commemorative Medal
Silver
6 cm diameter

James Butler RA
Small Smiling Head
Bronze
H 17 cm

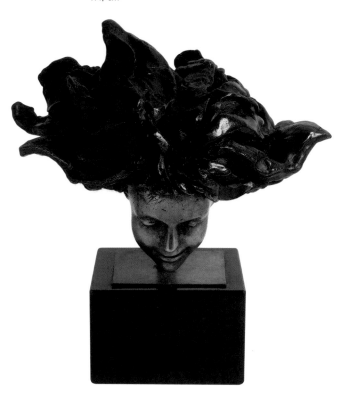

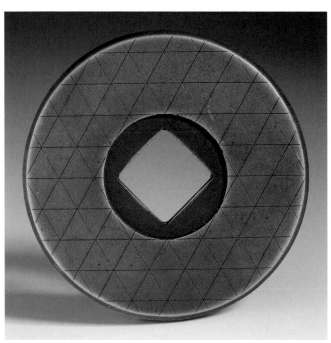

Ralph Brown RA
Europa with Her Bull
Bronze
H 23 cm

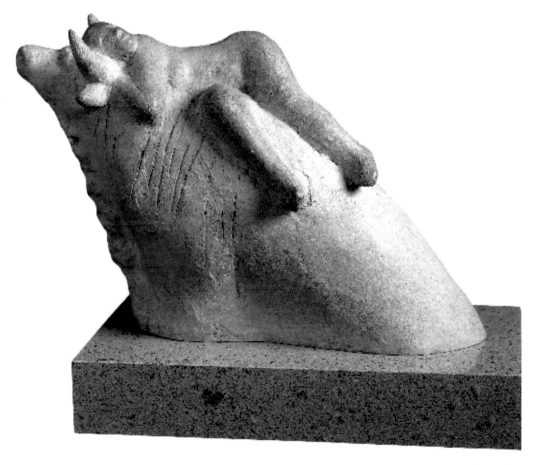

Ivor Abrahams RA
Caged Birds
Giclée print
113 × 97 cm

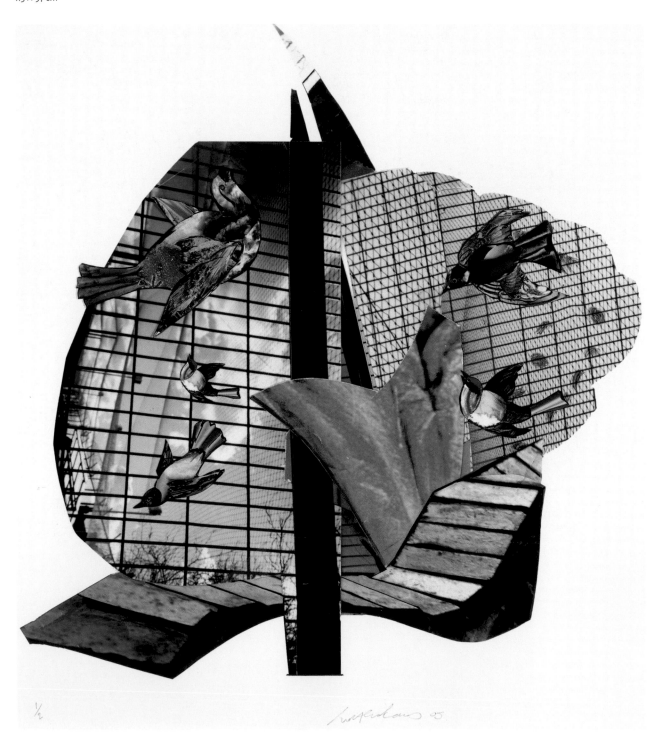

1/2

Kenneth Draper RA
Harvest Moon
Pastel
43 × 47 cm

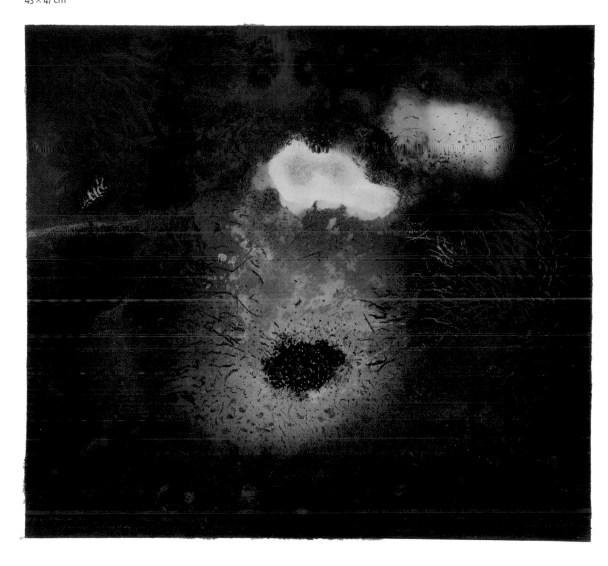

VIII

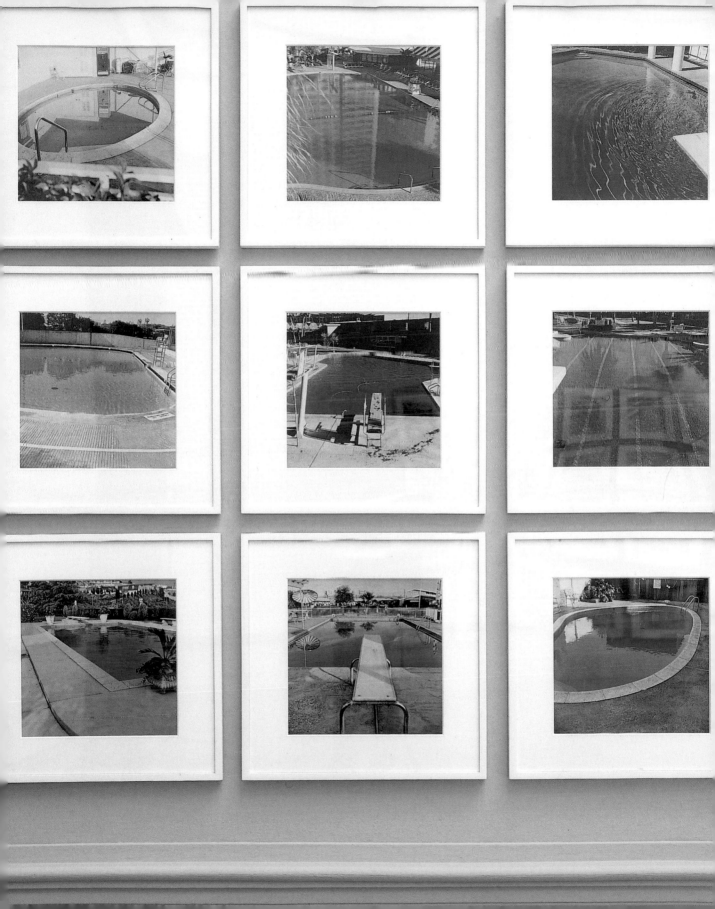

Ed Ruscha
Frank Whitford

For several years the Summer Exhibition has devoted a gallery to the work of a single Academician. In 2005 Gallery VIII is occupied by photographs, paintings and books by the American Ed Ruscha. This close attention is timely, since Ruscha is the most recently elected Honorary Academician.

Born in Omaha, Nebraska, in 1937, Ruscha moved to Los Angeles in 1956, where, for the next four years, he studied at what is now the California Institute for the Arts. By the early sixties he had won a reputation for his paintings, collages and printmaking, and for his association with such artists as Robert Irwin and Edward Kienholz. He soon became widely known for paintings and prints that incorporate words and phrases, and for his many photographic books. Given the period and the predominance of urban imagery in Ruscha's work, he inevitably became known as a Pop artist.

Many of Ruscha's earlier paintings and prints (not included in this display) isolate magnified signs, slogans, logos and single evocative words against bright, expansive colour fields. Beautifully rendered with meticulous, *trompe l'oeil* precision, they are presented in a variety of decorative typefaces, from mock Gothic to longhand, and sometimes in the kind of exaggerated perspective that comic book letterers developed to dramatise cover pages. The relationship between the word, the form of its letters, and its meaning is frequently linguistically and visually witty, even surreal. Sometimes, too, Ruscha created these images with ink made from such organic substances as wine, blood, axle-grease, gunpowder, caviar and even crushed tulips and daffodils. Sometimes the source of the ink was related to the word-image; sometimes not. Neither Ruscha nor his printer had the faintest idea of how time and light would treat these 'inks'. The intriguing possibility that they might fade and

disappear altogether simply added to the nature of the print, and the poker-faced humour of the exercise.

All of Ruscha's art contains subtle wit and calculated understatement. It is informed by the legendary laid-back attitude of the typical Californian. It is also more serious than it looks.

The work shown in Gallery VIII does not pretend to be remotely like a retrospective in miniature. It is a kind of taster, a brief, thought-provoking introduction to Ruscha's art. For one thing, Ruscha is representing the United States at the Venice Biennale this year, and so by no means all of his work was available to his friend Allen Jones, the Academician who arranged the display. But some important pieces are here; above all, perhaps, Ruscha's books of photographs, a full complement of which are laid out in the glass case. One of them is *Every Building on Sunset Strip* (1966), an accordion-fold volume consisting of a single sheet almost 25 feet long. It records in sequence every façade on the famous Los Angeles boulevard. Even-numbered addresses run across the top of the paper, odd-numbered addresses along the bottom. The street is entirely empty, even of cars, which prompted Andy Warhol to ask, when Ruscha presented him with a copy, 'How do you get all these pictures without people in them?' The depopulation of the street does indeed seem strange, even unreal. It seems stranger still in the selection of altered-negative photographs for the book exhibited on one wall.

Another of Ruscha's books, actually his first, is *Twenty-Six Gasoline Stations*. 'Twenty-six' and 'gasoline' are words that hold a special appeal for Ruscha. The title came to him before he took the photographs. He has no explanation for this. 'I've always had a deep respect for things that cannot be explained,' he says, 'Explanations seem to me to sort of finish things off.'

Among the other books displayed here is *Royal Road Test*, a piece of mock reportage investigating with appropriate seriousness what happened when someone threw a Royal typewriter out of the window of a moving car. Yet more of Ruscha's prosaic, precisely descriptive book titles are *Various Small Fires*, *Some Los Angeles Apartments* and *Business Cards* (with Billy Al Bengston). Business cards are indeed a special interest of Ruscha's, who has designed several of his own, mostly explaining how his name is pronounced ('Roo-SHAY'). Such a card was included in presentation and review copies of *Crackers*, a photonovel devoid of text which tells an utterly banal but curiously gripping story. Some of the photographs for two more of Ruscha's books are shown in this gallery. One is *Nine Swimming Pools*, another *Thirty-Four Parking Lots*, only thirty of which are included here. Even if unintentional, it is a good joke.

Unlikely though it may seem, Ruscha has carried out a number of public commissions in the United States. One involved painting a number of murals for the Miami-Dade Public Library in Miami, Florida (1985 and 1989). After he finished the work he discovered that there was a surplus of lunettes. Three of the unwanted semicircular canvases have been borrowed for this display, and they are clearly related to the small paintings lower down on the left-hand wall. Some of these canvases have been treated with bleach; others are straightforward acrylics. Paradoxically, these minimalist compositions are related to Ruscha's text paintings and prints, for the rectangles represent deleted (or censored) words, which together form phrases and sentences. These are revealed in the titles, two of which are representative: *I Will Wipe You Off the Face of This Earth* (page 151) and *Stick Up Don't Move Smile* (page 150). Perhaps smile is the word most relevant to Ruscha's work in general.

The installation of Ed Ruscha's books in Gallery VIII, including *Every Building on Sunset Strip*, 1966. Works from *Thirty-Four Parking Lots* hang in the background

Ed Ruscha HON RA

1 *Parking Lots: (Pershing Square Underground Lot, 5th and Hill), no. 1, 1967–99*
 Thirty silver–gelatin prints with mats, archival artist's crate

2 *Parking Lots: (Lockheed Air Terminal, 2627 N. Hollywood Way, Burbank) no. 2, 1967–99*

3 *Parking Lots: (Lockheed Air Terminal, 2627 N. Hollywood Way, Burbank) no. 3, 1967–99*

4 *Parking Lots: (Hollywood Bowl, 2301 N. Highland) no. 4, 1967–99*

5 *Parking Lots: (5000 W. Carling Way) no. 5, 1967–99*

6 *Parking Lots: (Eileen Feather Salon, 14425 Sherman Way, Van Nuys) no. 6, 1967–99*

7 *Parking Lots: (May Company, 6150 Laurel Canyon, North Hollywood) no. 7, 1967–99*

8 *Parking Lots: (7133 Kester, Van Nuys) no. 8, 1967–99*

9 *Parking Lots: (Good Year Tires, 6610 Laurel Canyon, North Hollywood) no. 9, 1967–99*

10 *Parking Lots: (Unidentified lot, Reseda) no. 10, 1967–99*

11 *Parking Lots: (Sears Roebuck & Co., Bellingham & Hamlin, North Hollywood) no. 11, 1967–99*

12 *Parking Lots: (Rocketdyne, Canoga Park) no. 12, 1967–99*

13 *Parking Lots: (Dodgers Stadium, 1000 Elysian Park Ave.) no. 13, 1967–99*

14 *Parking Lots: (State Dept of Employment, 14400 Sherman Way, Van Nuys) no. 14, 1967–99*

15 *Parking Lots: (Zurich–American Insurance, 4465 Wilshire Blvd.) no. 15, 1967–99*

1

2

6

7

11

12

3

4

5

8

9

10

13

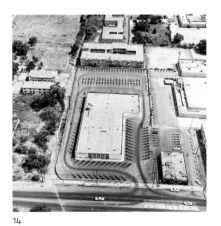

14

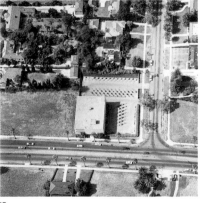

15

Ed Ruscha HON RA

1 *You and I Are in Disagreement (no. 33)*
 Bleach and acrylic
 50 × 40 cm

2 *I Can't Take It No More (no. 25)*
 Bleach on fabric–covered board
 50 × 40 cm

3 *I Will Wipe You Off the Face of This Earth
 (no. 39)*
 Bleach on fabric–covered board
 50 × 40 cm

4 *Stick Up Don't Move Smile (no. 29)*
 Bleach on board
 50 × 40 cm

5 *I'm Going to Leave More Notes and
 I'm Going to Kick More Ass (no. 38)*
 Bleach on fabric–covered board
 50 × 40 cm

6 *You Talk You Get Killed (no. 34)*
 Oil
 38 × 40 cm

1

4

2

3

5

6

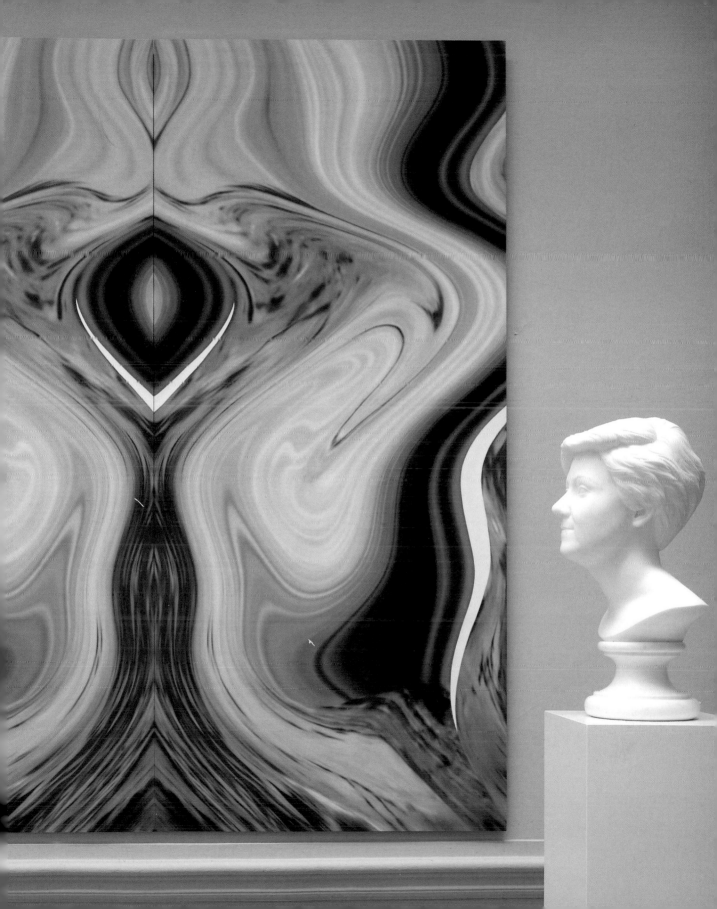

Alexis Harding
Cross (Yellow/Black)
Oil on MDF
183 × 183 cm

Callum Innes
Exposed Painting: Charcoal, Black, Deep Purple
Oil
227 × 227 cm

Henry Mundy
Untitled
Acrylic
122 × 137 cm

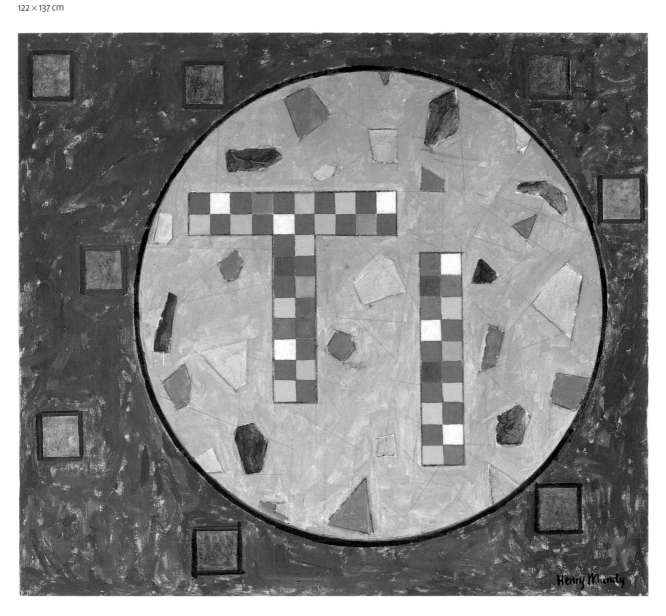

Sandra Blow RA
Multiple Four
Acrylic
122 × 122 cm

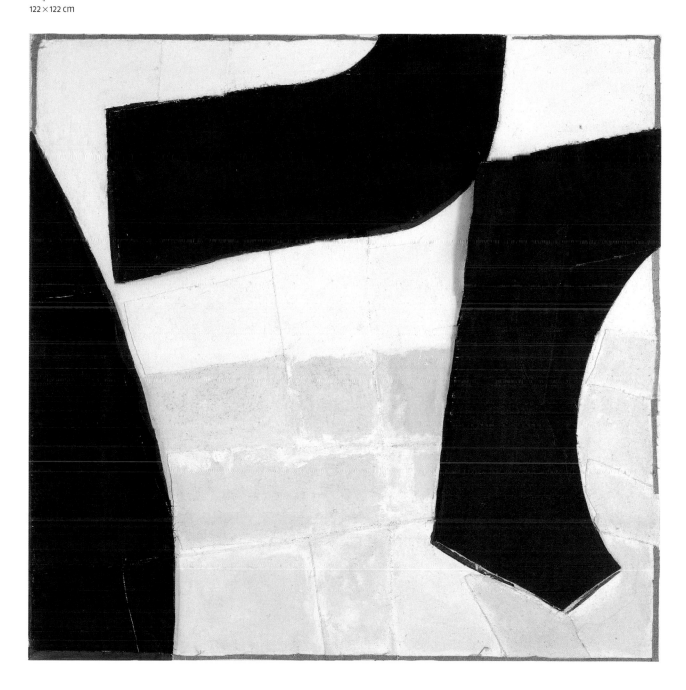

LECTURE ROOM

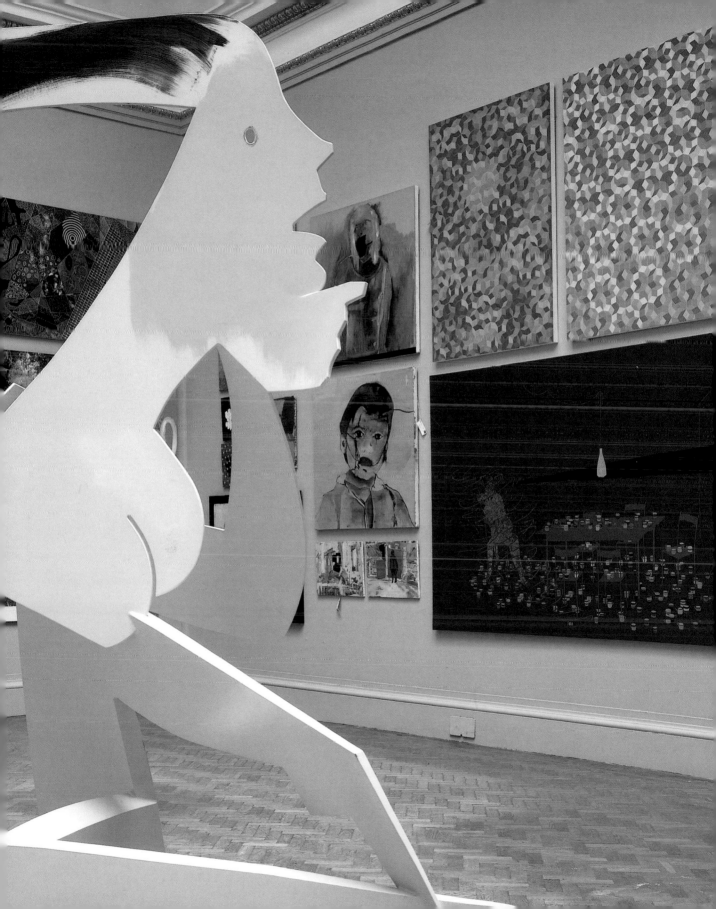

John Wragg RA
Benediction
Mixed media
62 × 62 cm

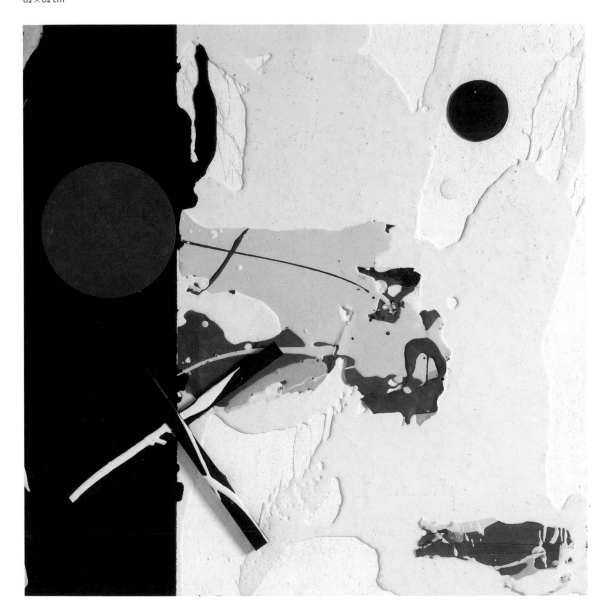

Prof David Mach RA
Rabbit Stew
Coat-hangers
H 50 cm

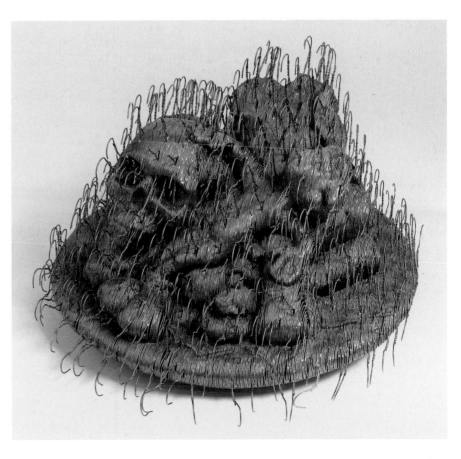

Sir Peter Blake CBE RA
Found Art 1: 'Penholders'
Inkjet
98 × 81 cm

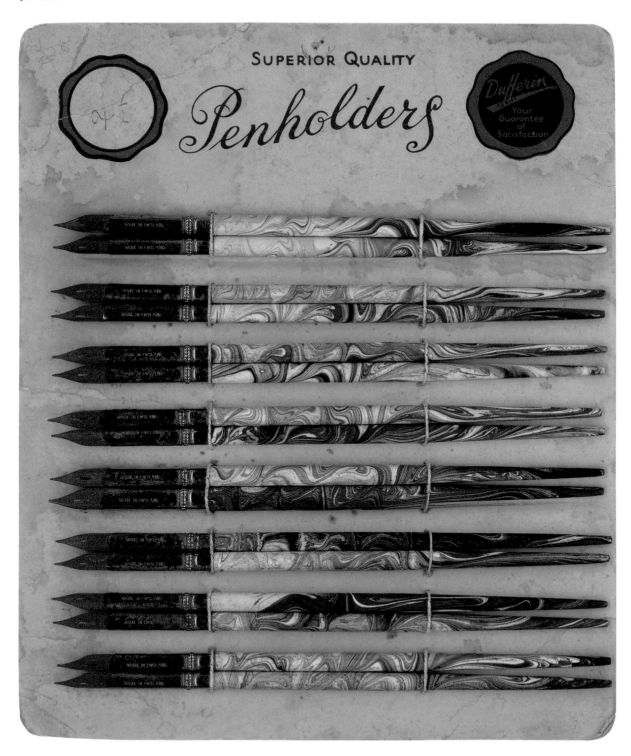

Sir Peter Blake CBE RA
Found Art 2: 'Seascape'
Inkjet
98 × 81 cm

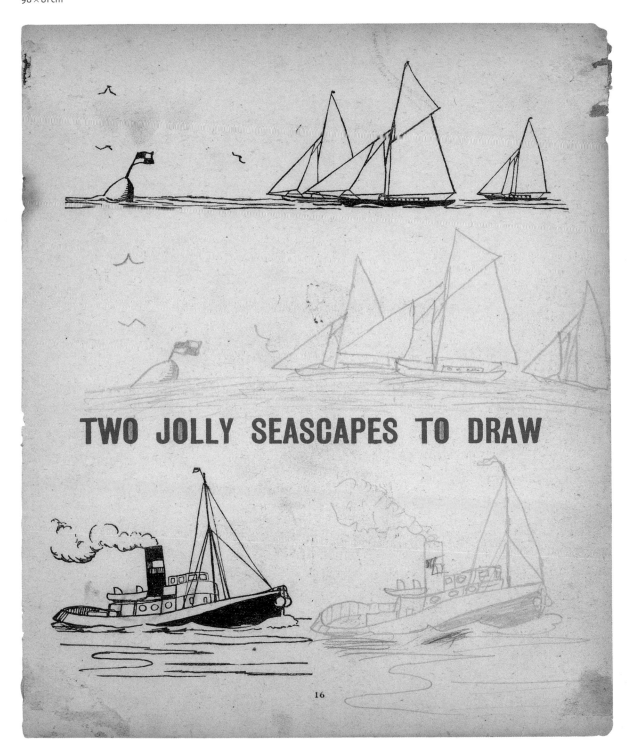

Therese Oulton
Untitled (L15) 1994
Monotype
60 × 90 cm

Dr William Baillie CBE
Kashmir Shrine
Oil
152 × 101 cm

Arturo di Stefano
House with London Plane
Oil
183 × 150 cm

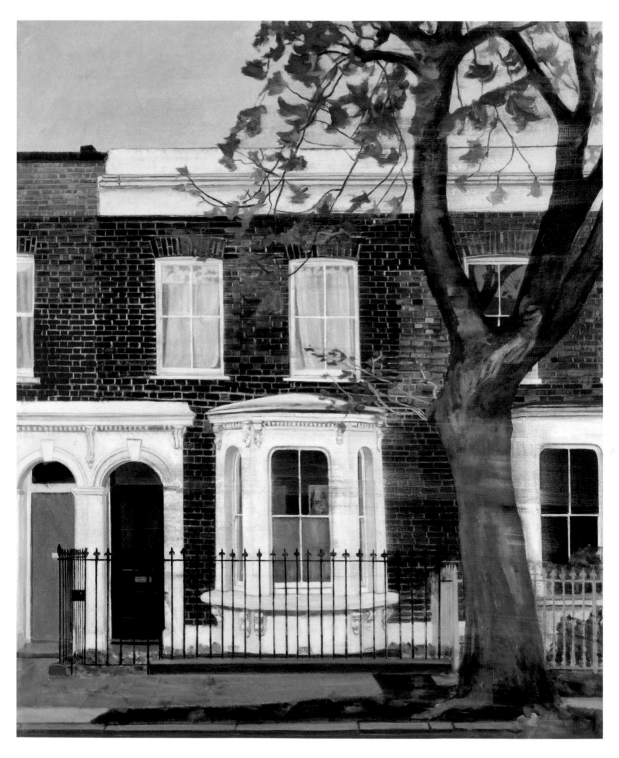

Adrian Berg RA
The Alhambra, Granada, 19 March + 3 April
Oil
61×76 cm

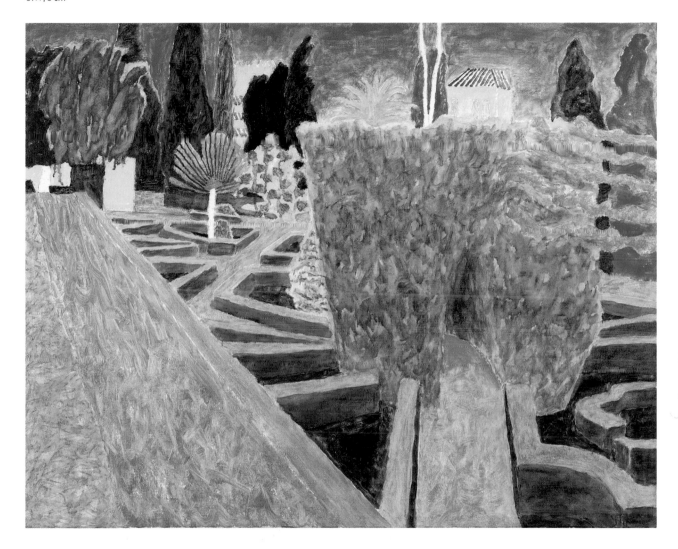

Richard Smith
Untitled
Oil
102 × 102 cm

Allen Jones RA
Standing Room Only (from *Sheet Music*)
Screenprint
103 × 83 cm

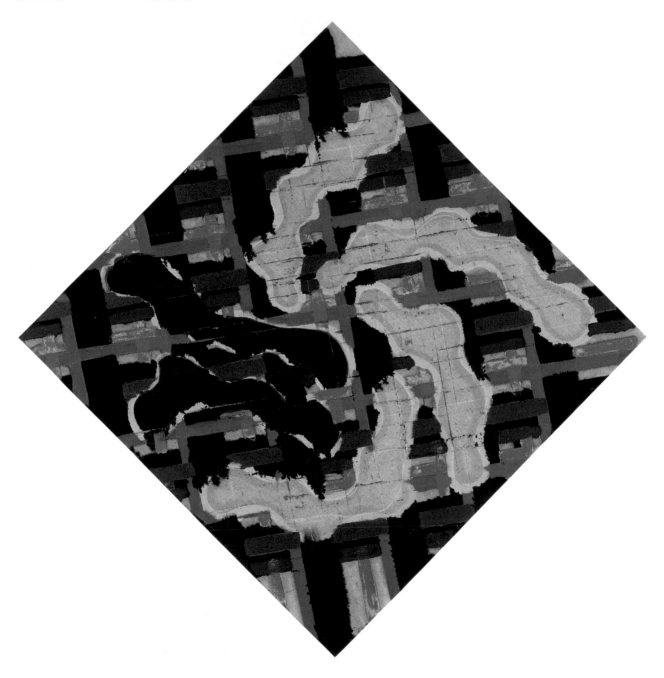

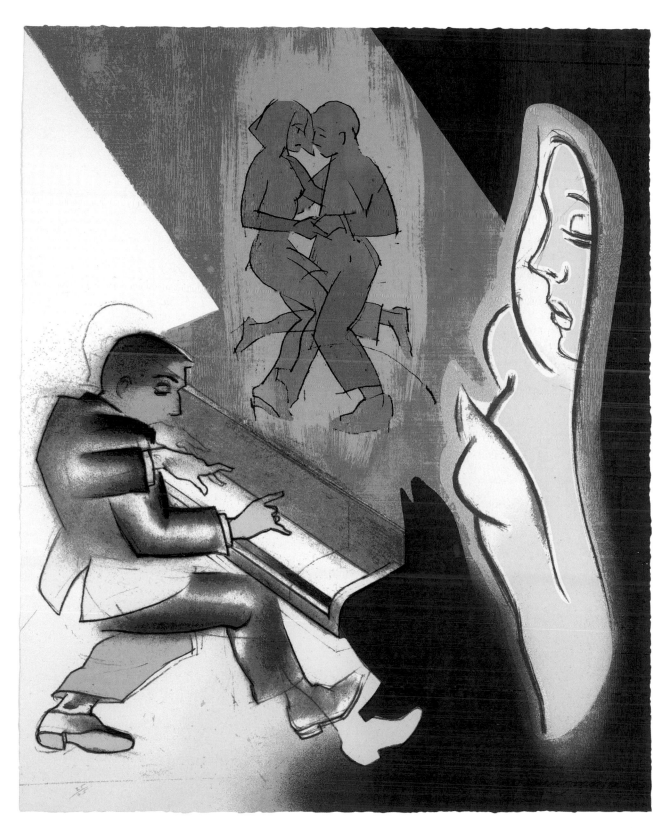

WOHL
CENTRAL
HALL

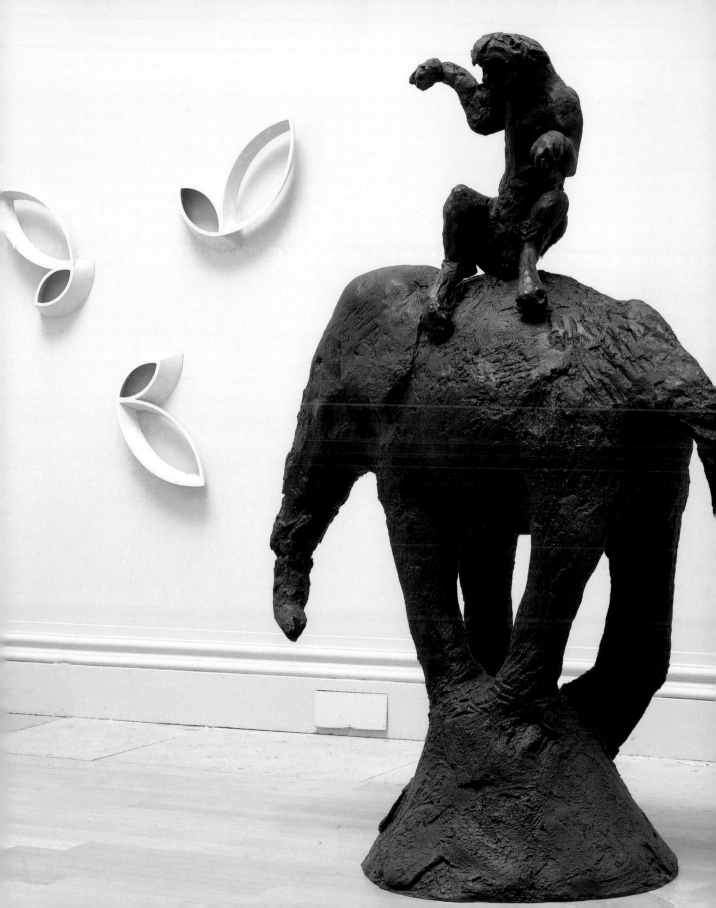

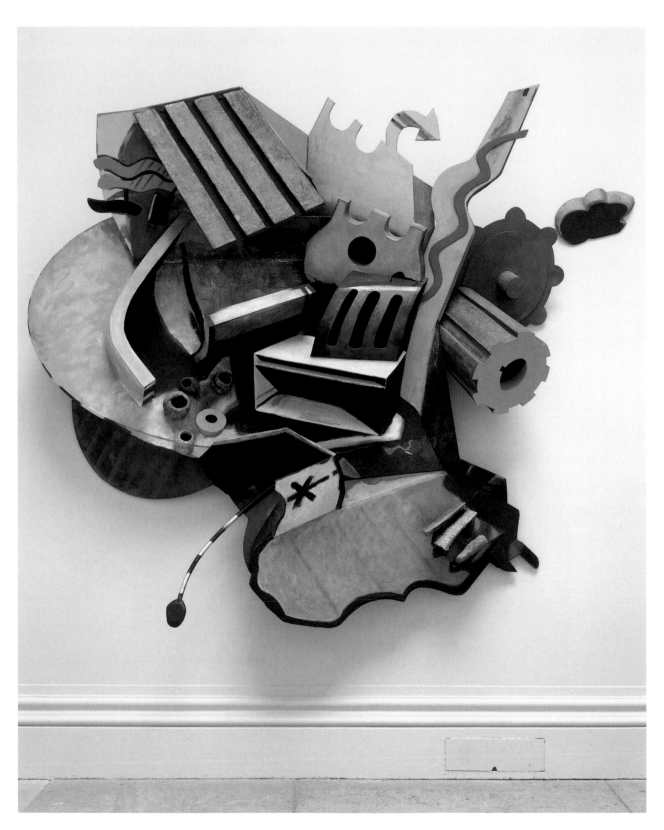

Gus Cummins RA
Off the Wall
Mixed media
256 × 277 cm

Sir Anthony Caro OM CBE RA
Cascade Series 'Mouchoir'
Steel
H 140 cms

Bill Woodrow RA
Beekeeper and Swarm
Mixed media
H 186 cm

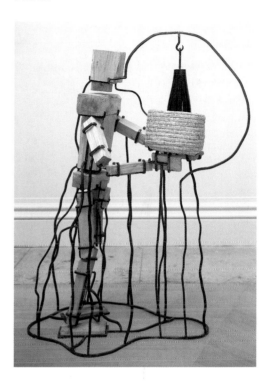

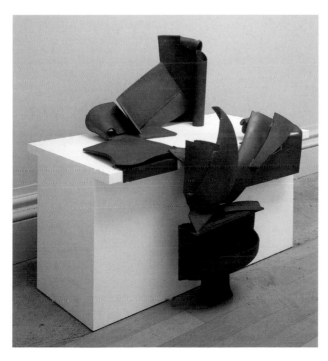

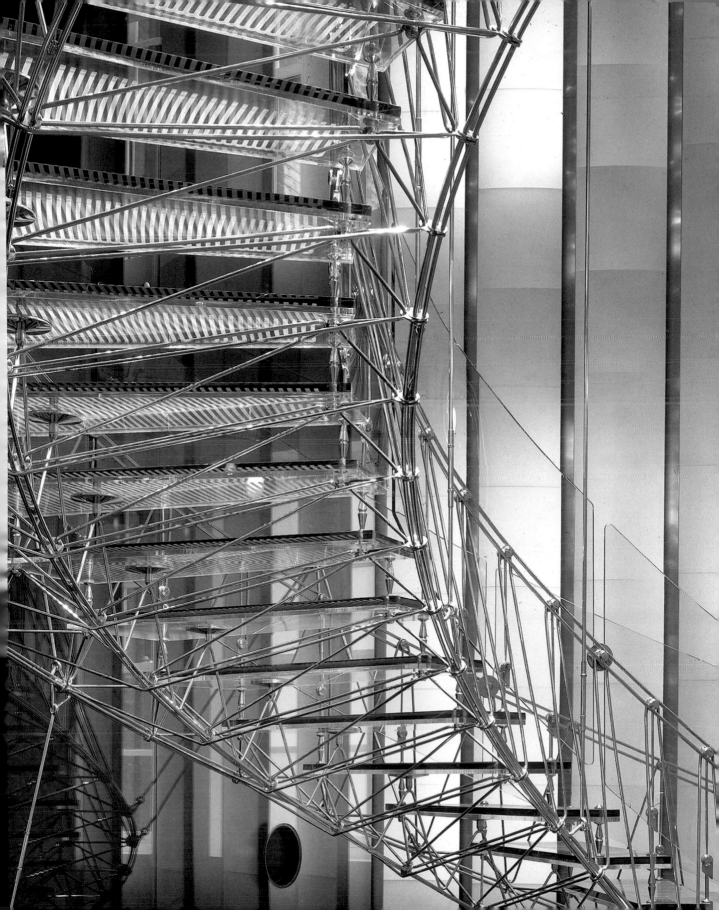

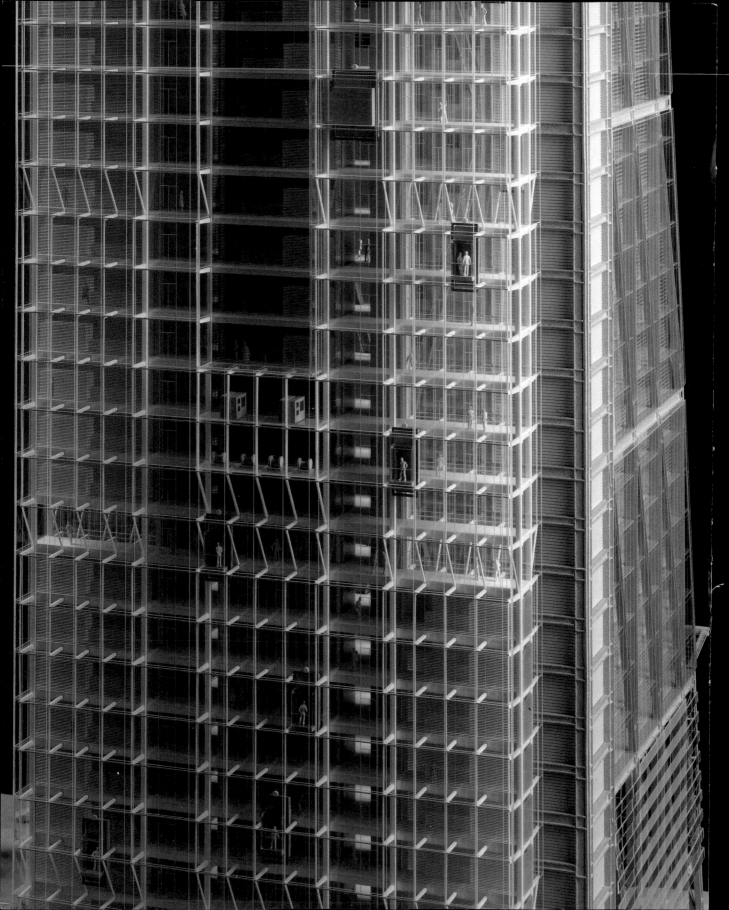

Lord Rogers of Riverside RA (Richard Rogers Practice)
Leadenhall Street (detail)
Model
H 134 cm

Lord Foster of Thames Bank OM RA (Foster and Partners)
Free University, Berlin (detail)
Model
H 16 cm

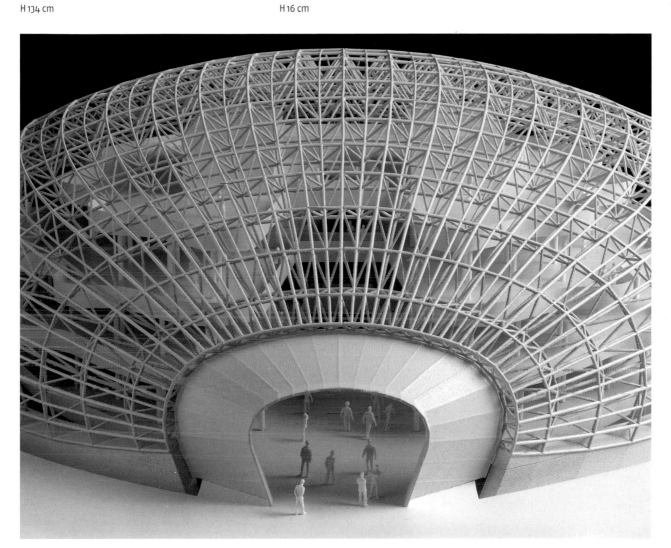

Prof William Alsop OBE RA
Between Travels (detail)
Acrylic
200 × 500 cm

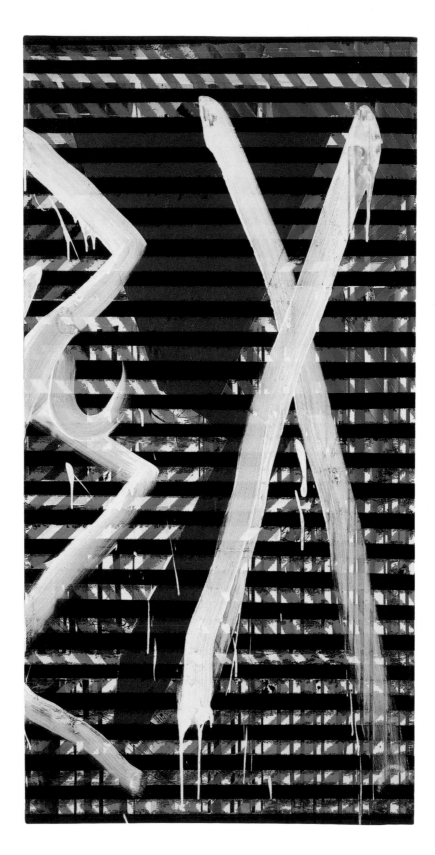

Leonard Manasseh OBE RA
Dada Design for a T–Shirt
Ink
27 × 27 cm

M³ Architects
Birmingham Jewellery Gate, mixed use tower
Model
H 26 cm

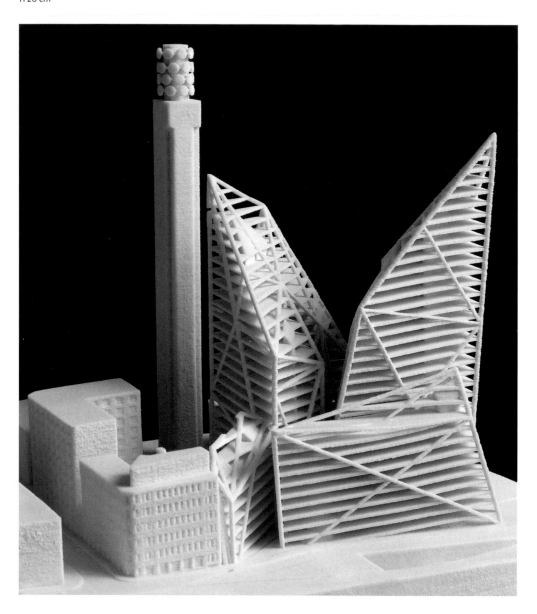

Eva Jiricna CBE RA (Eva Jiricna Architects)
Joan & David store, London
Transparency on lightbox (detail)
69 × 94 cm

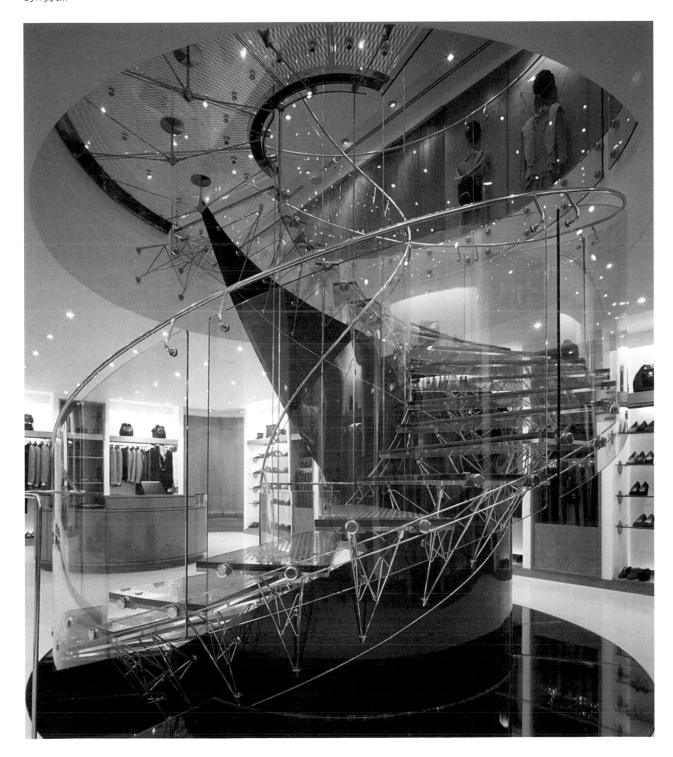

Michael Manser CBE RA (The Manser Practice)
Hotel at Wembley Stadium, North London
Inkjet
82 × 117 cm

Sir Michael Hopkins CBE RA (Hopkins Architects)
Antarctic Survey Halley VI Research Station
Inkjet
118 × 84 cm

Prof Ian Ritchie CBE RA
Leipzig Glass Hall
Model
H 30 cm

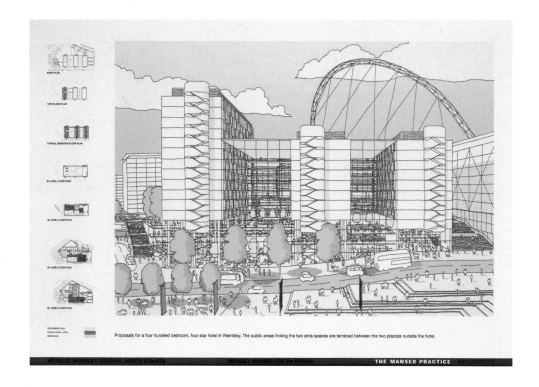

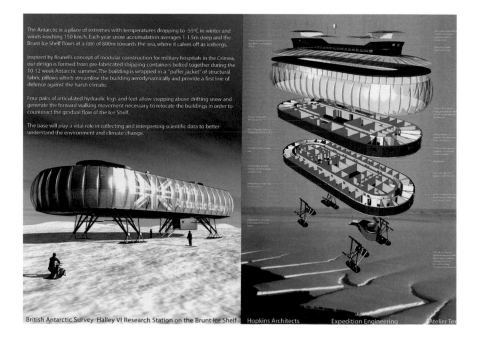

Prof Peter Cook RA (Peter Cook RA @ HOK)
London School of Economics (detail)
Model
H 65 cm

Edward Cullinan CBE RA
Penarth: Gateway Boulevard
Ink
50 × 67 cm

Sir Richard MacCormac CBE PPRIBA RA (MacCormac Jamieson Prichard)
Design for an Oxford College
Model
H 15 cm

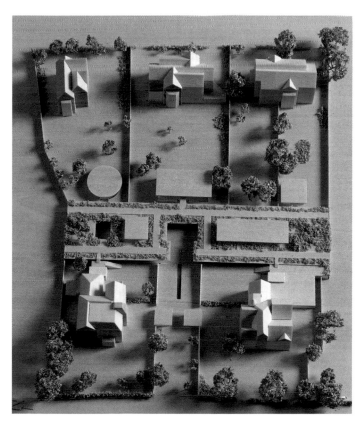

Boyd + Evans
ET 2004
Photographic inkjet
60 × 150 cm

Sir Nicholas Grimshaw CBE PRA (Grimshaw)
Interior View Fulton Street Transit Centre's Oculus
Digital print
104 × 77 cm

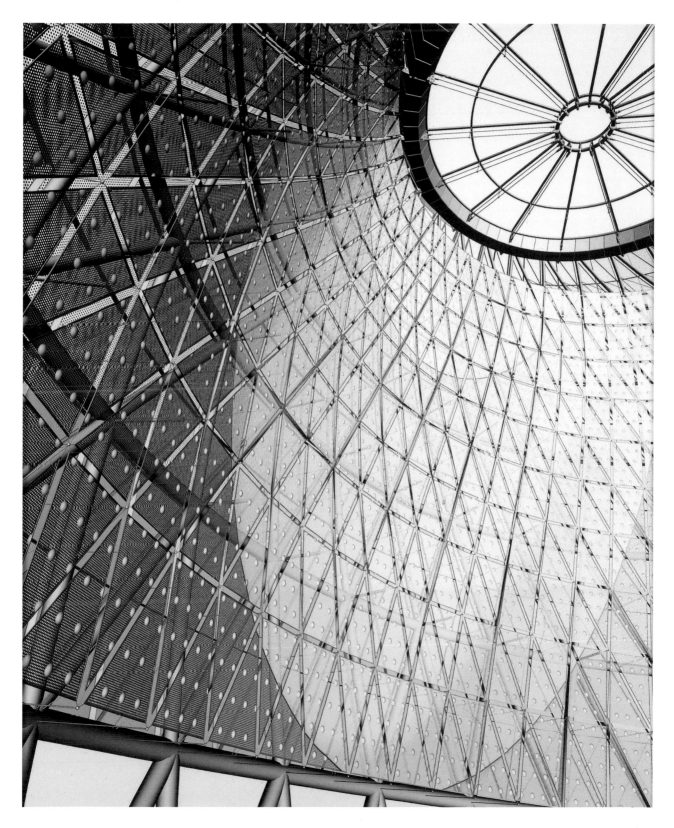

Index

Royal Academy Trust

Registered charity number 1067270

The Royal Academy of Arts has a unique position as an independent institution led by eminent artists and architects whose purpose is to promote the creation, enjoyment and appreciation of the visual arts through exhibitions, education and debate. The Royal Academy receives no annual funding via the government, and is entirely reliant on self-generated income and charitable support.

You and/or your company can support the Royal Academy of Arts in a number of different ways:

- £60 million has been raised for capital projects, including the Jill and Arthur M Sackler Wing, the restoration of the Main Galleries, the restoration of the John Madejski Fine Rooms, and the provision of better facilities for the display and enjoyment of the Academy's own Collections of important works of art and documents charting the history of British art.
- Donations from individuals, trusts, companies and foundations also help support the Academy's internationally renowned exhibition programme, the conservation of the Collections and educational projects for schools, families and people with special needs, as well as providing scholarships and bursaries for postgraduate art students in the RA Schools.
- Companies invest in the Royal Academy through arts sponsorship, corporate membership and corporate entertaining, with specific opportunities that relate to your budgets and marketing/entertaining objectives.

- A legacy is perhaps the most personal way to make a lasting contribution, through the Trust endowment fund, ensuring that the enjoyment you have derived is guaranteed for future generations.

To find out ways in which individuals, trusts and foundations can support this work (or a specific aspect), please contact Sharon Maurice on 020 7300 5637 to discuss your personal interests and wishes.

To explore ways in which companies can be come involved in the work of the Academy to mutual benefit, please telephone Joanna Conlan on 020 7300 5620.

To discuss leaving a legacy to the Royal Academy of Arts, please telephone Sally Jones 020 7300 5677.

Membership of the Friends

Registered charity number 272926

The Friends of the Royal Academy was founded in 1977 to support and promote the work of the Royal Academy. It is now one of the largest such organisations in the world, with around 87,000 members.

As a Friend you enjoy free entry to every RA exhibition and much more...

- Visit exhibitions as often as you like, bypassing ticket queues
- Bring an adult guest and four family children, all free
- See exhibitions first at previews

- Keep up to date through RA Magazines
- Have access to the Friends Rooms

Why not join today

- Onsite at the Friends desk in the Front Hall
- Online on www.royalacademy.org.uk
- Ring 020 7300 5664 any day of the week

Support the foremost UK organisation for promoting the visual arts and architecture – which receives no regular government funding. *Please also ask about Gift Aid.*

Summer Exhibition Organisers
Edith Devaney
Trine Hougaard
Tanya Millard
Katherine Oliver
Paul Sirr
Gillian Westgate

Royal Academy Publications
David Breuer
Harry Burden
Claire Callow
Carola Krueger
Peter Sawbridge
Nick Tite

Book design: 01.02
Photography: FXP and John Riddy
Colour reproduction: DawkinsColour
Printed in Italy by Graphicom

British Library
Cataloguing-in-publication Data
A catalogue record for this book
is available in the British Library

ISBN 1-903973-62-7
ISBN 1-903973-78-3 (special edition)

The multiple *Beauty Adorns Virtue*,
2005, created by Gary Hume RA,
is included in the special edition
of 3,000 copies

Illustrations
Page 2: Mimmo Paladino HON RA,
 Olympia (detail)
Page 4: Chuck Close, *James* (detail)
Page 9: The Late Prof Sir Eduardo
 Paolozzi, *Calcium Night Light III,
 Central Park in the Dark Some
 40 Years On*, 1974–76 (detail)
Page 21: Georg Baselitz HON RA,
 Negativphoto Morgens
Page 27: John Maine RA, *Pyramid II*;
 Chuck Close, *James* and
 Self-portrait/Pulp
Page 93: Donald Hamilton Fraser RA,
 Poinsettia (detail)
Page 103: Robert Clatworthy RA,
 Horseman and Eagle
Page 113: Tom Phillips CBE RA, *If I've
 told you once* (detail)
Page 131: Cathy de Monchaux,
 *Sweetly the Air Flew Overhead
 –Battle no. 4* (detail)
Page 145: Ed Ruscha HON RA,
 Swimming Pools (portfolio
 of nine prints)
Page 153: left, Marc Quinn, *Mirror
 Painting – Enlarged Section*
 (detail); right, Marc Quinn, *Anna
 Cannings (Blind from Birth)*
Page 159: left, Allen Jones RA,
 Femme assise; top right, Michael
 Kidner RA, *Blowing Bubbles* and
 Hidden Eyes in the Forest
Page 171: left, Nigel Hall RA, *Drifter
 Triptych*; right, Barry Flanagan
 OBE RA, *Large Elephant and
 Cougar*
Page 175: Eva Jiricna CBE RA
 (Eva Jiricna Architects Limited),
 Mayfair Apartment Stair